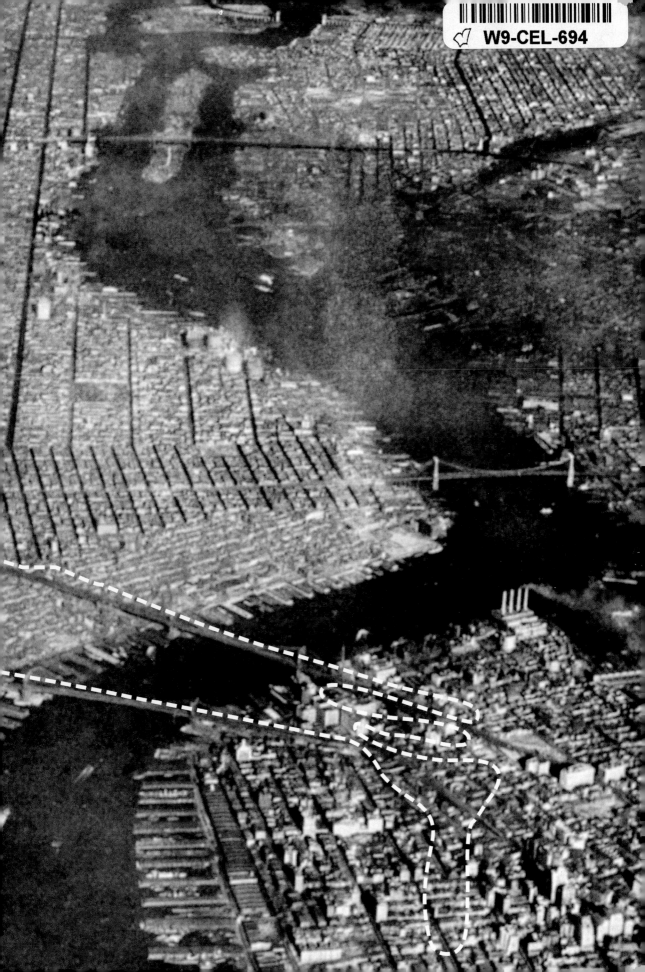

This project is dedicated to my father, Thomas Whiteread (1928–1988),
whose interest in industrial archaeology enabled me to look up.
—Rachel Whiteread

LOOKING UP

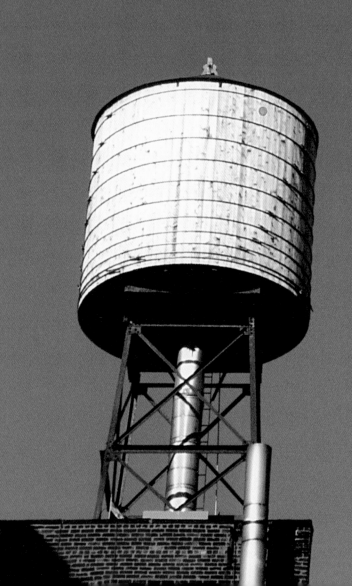

LOOKING UP

Rachel Whiteread's Water Tower

A project of the Public Art Fund

Edited by Louise Neri

Public Art Fund, New York City
Scalo Zurich – Berlin – New York

New York City; slide found in Brick Lane, London, 1987

East Village, 1991

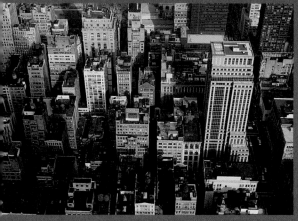

Looking south from Empire State Building, 1991

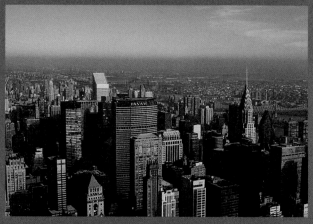

Looking north from Empire State Building, 1991

Midtown, 1991

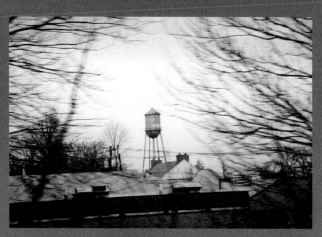

New Haven, CT, 1991

BeCa, 1991

TriBeCa, 1991

Lower East Side, 1993

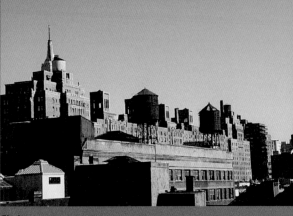

Chelsea, 1993

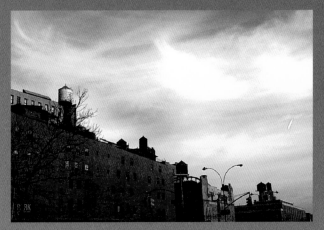

Chelsea, 1993

26th Street, 1993

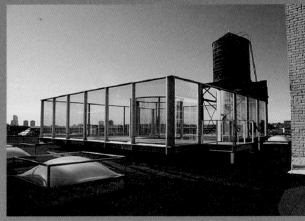

Dan Graham's *Two Way Mirror Inside Cube*,
Dia Center for the Arts, Chelsea, 1993

Lexington Ave., 1993

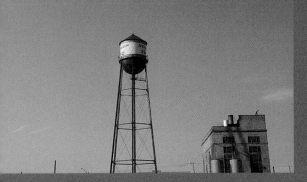

ffalo, NY, 1995

Chelsea, 1997

Battery Park City, 1997

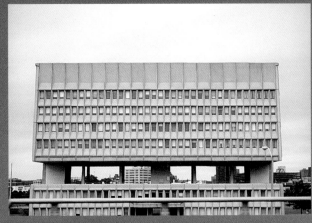

Pirelli Building, New Haven, CT, 1997

st Village, 1997

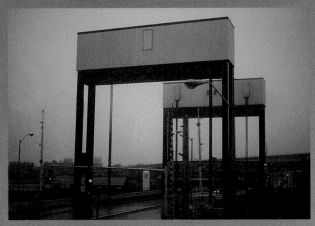

New Jersey, 1995

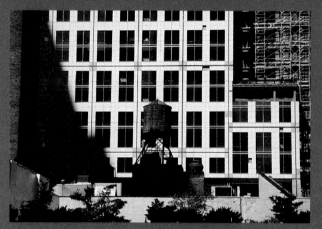

Midtown, 1998

New York Times, West Village, 1998

Rubbish, 1998

West Village, 1998

West Village, 1998

PREFACE

Public art projects combine the singularity of artistic vision with organizational and individual pragmatism. Above all, they demand a leap of faith into the realms of impossibility from all those involved. Rachel Whiteread's *Water Tower* is, to date, the Public Art Fund's most ambitious project. From its many participants it required creativity, resourcefulness, ingenuity, and willingness to experiment at every stage of its development and execution.

From Whiteread's original proposal evolved a daunting list of technical and logistical challenges that took almost four years to meet. We are extremely grateful to the many supporters who so generously provided the financial backing for the project; the water-tank fabricators and resin manufacturers who bent the rules of their craft; the engineers who tackled the structural problems posed by the concept; the city officials who expedited our unusual permit requests from the bureaucratic paperchase; the crane operators, technicians and assistants who were willing to work literally around the clock; and the building owners who gave their rooftop for this extraordinary sculpture. Their combined efforts made *Water Tower* possible.

I greatly admire and appreciate Rachel's vision and perseverance in bringing *Water Tower* to fruition, and I am extremely proud of the Public Art Fund's incentive, led by Director Tom Eccles who kept the countless elements and personnel involved in the process engaged, enthused, and on track.

This is the Public Art Fund's first major book. At Rachel's suggestion, we engaged Louise Neri, a New York-based editor and curator and a close friend of the artist, to develop and realize its structure and form. Her passion and insight have brought together a vast and diverse range of voices in a lively, incisive, and open-ended investigation of the broader meaning and potential of art in public places.

Rachel once declared her modest intention for *Water Tower* was to make New Yorkers simply stop and look up. As this book bears witness, her "jewel on the skyline" may have succeeded in doing just that.

SUSAN K. FREEDMAN
President, Public Art Fund

This publication is made possible by the generous support of

Vicki and Kent Logan
Bloomberg News

CONTENTS

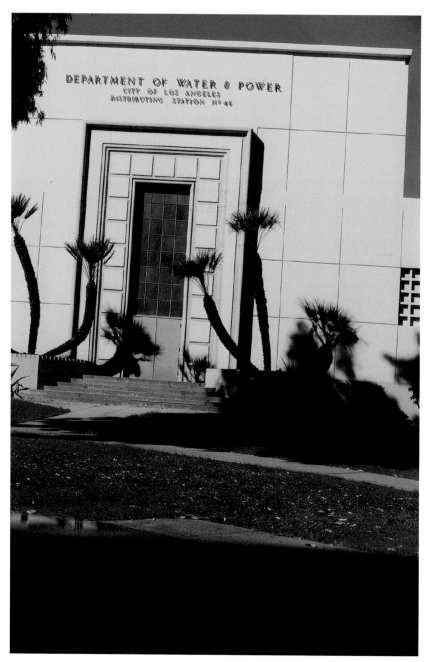

Richard Prince, *Department of Water & Power. Los Angeles, Calif., Fall 1991*

The trouble with water is that you just don't know where it's been.

It is, however, not true that the water we drink from the faucet has passed through several bodies en route to its passage through our own.

Average water usage in the U.S. is approximately 50 gallons per person per day.

Water costs about $2 per 1000 gallons. Of this amount, 30 cents are for treatment, and the rest (excluding profit) pays the mortgage on the treatment plant, the conveyance of the water, the maintenance of pipework, and the salaries of the utility company workers.

The New York City distribution system contains approximately 6,180 miles of pipe, 88,633 mainline valves, 103,661 fire hydrants, 6 distributing facilities, 16 gatehouses, 15 pump stations, and 11 maintenance and repair yards.

According to the Department of Environmental Protection's Water Supply Statement of 1997, over 90% of New York City's 1.3 billion gallon daily water consumption is groundwater collected from a 1,969 square mile watershed.

Quoting Bernard De Voto, Joan Didion wrote: "The West begins where the average rainfall drops below twenty inches. Water is important to people who do not have it, and the same is true of power."
(*The White Album*, 1979)

In *Adult Comedy Action Drama* (1995), Richard Prince makes his own laconic observation regarding such connections. On p. 153 is an image of the Department of Water & Power in Los Angeles, California from Fall 1991.

That same photograph is reproduced on the inside jacket of Courtney Love's *Celebrity Skin*, an album cryptically dedicated "To all the stolen water of LA and to anyone who ever drowned."

In the movie *Chinatown*, Robert Toyne depicts water as the incestual connection between power and ancestry, a dirty yet transparent secret passed along aqueducts and oviducts, from place to place, from generation to generation, diverted by developers away from agriculture to the city.

In arid climates, water is the liquid capital on which dynasties flourish or founder.

"Gentlemen," declares Mayor Bagby in an opening scene from *Chinatown,* "Today you can walk out that door, turn right, hop on the streetcar and in twenty-five minutes end smack in the Pacific Ocean. Now you can swim in it, you can fish in it, you can sail in it—but you can't water your lawns with it, you can't irrigate an orange grove with it. Remember: We live next to the ocean but we also live on the edge of the desert. Los Angeles is a desert community. Beneath this building, beneath every street there's a desert. Without water, the dust will rise up and cover us as though we had never existed."

In the state of New York the average annual rainfall is 42–43 in.

"Before this, I turned on the faucet, it came out hot and cold, I didn't think a thing of it." —Gittes, the private investigator in *Chinatown.*

Those of us who live in such temperate parts of the world think about water rarely since we take its presence for granted. Yet the social and historical structure of the city owes its form to the availability of water to combat fire and disease.

"New York," says Andrew Rosenwach, president of Rosenwach Tank Co., the original and one of two main operations still building wooden tanks in New York City, "is, in our mind, a tank town."
(*Pipelines,* Spring 1998)

Pipelines is the quarterly newsletter of the American Family of Tank, Plumbing and Cooling Tower Specialists.

Buildings, like bodies, are serviced by subcutaneous arterial systems largely invisible from the outside. Stop-cocks, faucets, pressure valves, and drains regulate a system based on supply and demand.

Early settlers in Manhattan obtained water from shallow privately owned wells. In 1677 the first public well was dug in front of the old fort at Bowling Green.

In 1776, when the population reached approximately 22,000, a reservoir was constructed on the east side of Broadway between Pearl and White streets.

Water pumped from wells sunk near the Collect Pond, east of the reservoir, was distributed through hollow logs laid in the principal streets.

In response to the fires that ravaged the City thoughout the summer of 1830, and to the cholera epidemic of the same year, a tank was constructed by the City at 13th Street and Broadway and was filled from a well. Water from the tank was distributed through two 12-inch cast iron pipes.

After exploring alternatives for increasing supply, the City decided to impound the water from the Croton River in what is now Westchester county, forcibly cementing the relationship between the concentrated form of urban interior and the rural beyond.

At 5 a.m. on June 22, 1842, water was admitted into the Croton aqueduct for the first time. Twenty-two hours later, water emerged at the Harlem River end of the line, followed shortly thereafter by a small boat called the Croton Maid and its intrepid crew.

The Croton system — now a series of twelve reservoir basins in Putman, Westchester, and Duchess supplying a mere 10% of the daily metropolitan water consumption — provides a natural water pressure from the head of a reservoir approximately 300 ft. above sea level.

The water that I will draw from my tap tomorrow in New York City is passing today through City Tunnel No. 1 on an 18-mile underground journey from Hillsview Reservoir in Yonkers down to the smaller rooftop reservoir that is my water tank.

Natural pressure of approximately 40 pounds per square inch (psi) is created by the head of water that is the holding reservoir. This is sufficient to force the water to a height of five to six storeys above grade.

Water pressure is regulated within a range of 35 to 60 psi at street level. About 95% of total consumption is delivered by gravity.

Water towers are diurnal valves: emptied during the daytime where peak demand causes pressure to drop and filled up again at night.

Prior to the advent of efficient mechanical water pumps at the end of the nineteenth century, few buildings exceeded the height of the natural water pressure.

Water towers are the architectural manifestations of a fluid architecture that connects the atmospheric to the subterranean, the rainfall of the watertable to the underground supply network.

The skyline of old New York is the engineering consequence of the reserves of water held in upstate regions.

According to current estimates there are 17,000 rooftop water tanks in New York City. (*Pipelines,* Spring 1998)

"The poetry of New York is not that of a practical concrete building that scrapes the sky: the poetry of New York is that of a many-piped organ of red ivory — it does not

scrape the sky, it resounds in it with the compass of the stysole and diastole of the
visceral canticle of elementary biology..."
Salvador Dali quoted by Rem Koolhaas in *Delirious New York, 1994*

The economy of water operates on the scale of supply and demand. In 1905, increases
in demand led to the creation by the State Legislator of the Board of Water Supply.

Its first project was the development of the Catskill System. The Board of Water Supply
proceeded to plan and construct facilities to impound the waters of the Esopus Creek,
one of the four Catskill watersheds.

New York City is currently served by three systems — the Croton, Catskill, and Delaware
systems — linking nearly 2,000 square miles of watershed to 8 million residents.

To ensure the quality of the New York City water supply, the City has instigated
an aggressive ten-year, $260 million program to acquire hydrologically sensitive
watershed land and protect it from the effects of human habitation.

Human habitations must be protected from their own effects.

In New York City the sewage charge — the water used in the disposal of human
waste — constitutes approximately two thirds of a building's entire water bill.

In 1997, the Department of Environmental Protection exceeded the first year's goal
of soliciting the owners of 56,609 acres of watershed land, placing 9,100 acres of land
under purchase contracts worth $24 million, and closed on 147 acres.

Litigation on behalf of 45 property owners in the upstate watershed, seeking damages
of approximately $10.5 billion in the aggregate for the alleged diminution in value
of their property caused by a chilling effect on the real estate market from the City's
regulatory program, is pending following a denial in June of 1997 of the City's motion
to dismiss this suit.

The same litigation asserts claims for the unconstitutional taking of property without
just compensation. The City has also received approximately 80 additional claims from
individual property owners not party to the joint litigation, seeking similar relief.

"Yeah — they've been blowing these farmers out of here buying their land for peanuts.
Have any idea what this land'll be worth with a steady water supply? About 30 million
more than they paid."
— Gittes in *Chinatown.*

In present-day New York City, the politics of land values can be read in the architecture of the skyline. Water, like any other system, is political: power that can be channeled, streamed, diverted and stored.

All surface and groundwater entering New York City's distribution system is treated with chlorine, orthophosphate, and in some cases, sodium hydroxide.

Orthophosphate is added to create a protective film on pipes which reduces the release of metals such as lead from household plumbing.

A sequestering phosphate is added to keep naturally occurring minerals, mainly iron and manganese, from settling out in distribution and household plumbing.

Since the mid-1960s a small amount of fluoride — one part per million — has been added to the City's water supply in accordance with the New York City Health Code.

Watertowers have, since that time, become one of the visible manifestations of a City-wide program to prevent tooth decay.

Traditional wooden watertowers have been depicted by Stieglitz, Hopper, Sheeler, Abbott, the Bechers, Feininger, Kertesz, and others.

The construction of wooden tanks has changed little over the past century and is laid out by a National Fire Protection Association (NFPA) standard.

All lumber designated for tank construction shall be well-seasoned and free from rot, sap, loose or unsound knots, wormholes and shakes in accordance with the *National Wood Tank Institute Bulletin S82.*

As defined by the NFPA 22 Standard for Water Tanks for Private Fire Protection, a holiday is "A discontinuity in the coating system including but not limited to voids, cracks, pinholes or scratches."

Untreated lumber in the staves and bottom shall be thoroughly air-dried (below 17% moisture content) "All Heart" or "Tank Stock" without any sapwood after shaping. Acceptable untreated species shall be redwood, western yellow cedar, southern white cedar (dismal swamp), western red cedar and Douglas fir (coast type), the varieties being arranged in order of preference.

The lumber in the staves and bottom of the tank should be according to the prescribed specifications at least $2\frac{1}{2}$ in. nominal dressed to not less than $2\frac{1}{8}$ in. thickness for tanks less than 20 ft. in depth or diameter.

The standard sizes of wood tanks are 5000 gal., 10,000 gal., 15,000 gal., 20,000 gal., 25,000 gal., 30,000 gal., 40,000 gal., 50,000 gal., 60,000 gal., 75,000 gal. and 100,000 gal. net capacity. Tanks of other sizes are built.

Wooden tanks, if well-maintained, are expected to last upwards of 30 years.

Since most of the water we consume is held suspended in the upper atmosphere it is appropriate that *Water Tower* is transparent.

Water towers were originally designed to provide a static head of water held in momentary abeyance of the laws of gravity. Rachel Whiteread's *Water Tower* is filled only with atmosphere.

To look at Whiteread's *Water Tower* is not only to be reminded of the origins of what we take for granted but also to delve into the functioning of a larger system of which wooden water towers are merely the visible pinnacles.

On August 13, 1998, eight weeks after the installation of *Water Tower* on a SoHo rooftop, Mayor Giuliani inaugurated City Water Tunnel No. 3, the largest capital improvement project in the City's history.

The construction of City Water Tunnel No. 3 began in 1970 and has so far cost $1,000,000,000 and 24 lives.

At its deepest, below Roosevelt Island, the tunnel is between 700 and 800 ft. below ground, its finished diameter nearly twice that of the base of *Water Tower*.

Upon completion, the flow of City Water Tunnel No. 3 will be operated by four large underground valve chambers. The largest of the valve chambers is at Van Cortland Park, built 300 ft. below the surface and 620 ft. long (longer than two football fields placed end to end).

"The activation of City Water Tunnel No. 3 marks the culmination of a century of strategic water planning in New York City."
— Mayor Giuliani's inaugural address, August 13, 1998

Water Tower is also a monument to the culmination of a water distribution system that has remained largely unchanged for 160 years.

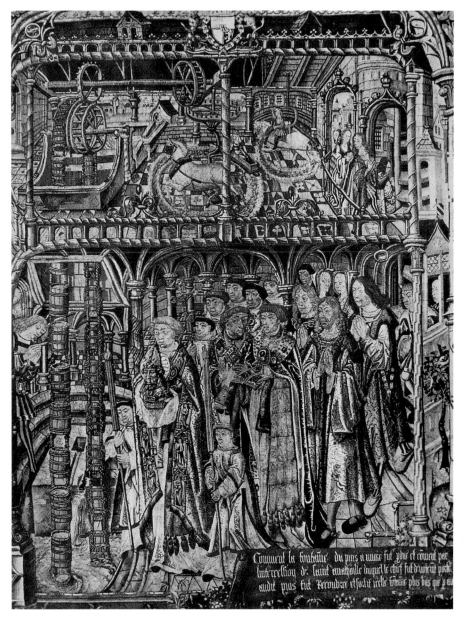

The Miracle of Water, one of four tapestries of *The Miracles of St. Anatole,* Bruges, 16th century

Ilya Kabakov, *Monument to the Lost Glove*, 23rd Street, New York City, 1997–98

VANISHING POINT:
THE MAKING OF *WATER TOWER*

Rachel Whiteread's *Water Tower* began in 1994 with a visit to New York.
During this period, the Public Art Fund had expanded its commissioning
process to invite artists from beyond New York City to investigate sites of
their choosing for temporary installations. The first such project, Christian
Boltanski's *Lost: New York Projects* (1995), transformed sites in four landmark
buildings (a Lower East Side synagogue, a Harlem church, the corridor of
a civic museum, and the waiting room of Grand Central Station) into potent
experiences of individual and collective loss and resurrection. For six months
Boltanski collected New York's lost property, mountains of second-hand
clothing, the tape-recorded memories of Lower East Side children and the
entire possessions of an anonymous apartment dweller for installations that
represented New Yorkers with a pseudo-anthropology of past and present.
Alexander Brodsky, a Russian artist who had participated in the Muscovite
Paper Architects group in the 1980s (known for their ironically extravagant
and unrealizable submissions for state-run competitions), selected the dis-
used track of the Canal Street subway station at Broadway for an installation
of rudimentary gondola-like boats floating on a water-filled tank in 1996.
The resulting sculptural passageway, more Vietnamese than Venetian, was
a dark existential theater in the bowels of commuter hell. Ilya Kabakov's
Monument to the Lost Glove (1997–98), a mysterious red resin glove sur-
rounded by eight lecterns engraved with the accounts of fictional passersby,
sited on the traffic triangle in front of the Flatiron Building at 23rd Street,
further demonstrated the shift from object to urban dialogue as the focus
of the Public Art Fund's curatorial direction. These and other projects also
suggested the possibility for subtle, poetic narratives and fictions to be liter-
ally dropped into the stream of urban life.

 Incrementally, these projects moved the Public Art Fund towards
a new operating model. More "producer" than public art manager, we became
integrally involved in identifying potential locations, fixing budgets, raising
funds, and finding solutions to a wide array of technical problems raised by
the artists invited to address the city as a site for their work. Bringing political,

David Hammons, *Message to the Public,* Times Square, New York City, 1982

organizational, and technical support to the work of the artist, obtaining permits, and securing bureaucratic approvals are all elemental steps in the realization of the artist's vision.

These projects also changed the correspondence between "sites" and artistic practice. While each work clearly "fit" its selected site, none of the works presented was precisely "site-specific" in the sense of referring directly to its location. Artists were more likely to investigate a site typologically than historically. The works temporarily lent the spaces they occupied a universal rather than local meaning, in contrast to the prevailing public art practice which often renders the commission as something of an archeological dig.

The Public Art Fund's positioning of the artist within an urban cultural dialogue presents projects not so much by confronting—though that is always present—but rather by engaging the intelligence and natural inquisitiveness of the passerby. While the installations are generated from the artist's own vocabulary, and maintain a certain density as artworks—unlike advertising which can be immediately decoded to reveal a single proposition—the projects in their city locations are "open texts" which invite many possible readings and individual perceptions. This humanistic philosophy presents artists and their art as significant participants in the public life of the city. In this context, artists become important advocates for democratic values, maintaining the belief that public land is an arena for public life. But, of course, democracy is a fraught territory, which in Britain propelled the unlikely figure of Rachel Whiteread into national and international headlines.

We began discussions with Rachel Whiteread six months after the destruction of *House.* Her concrete interior casting of an East-End London

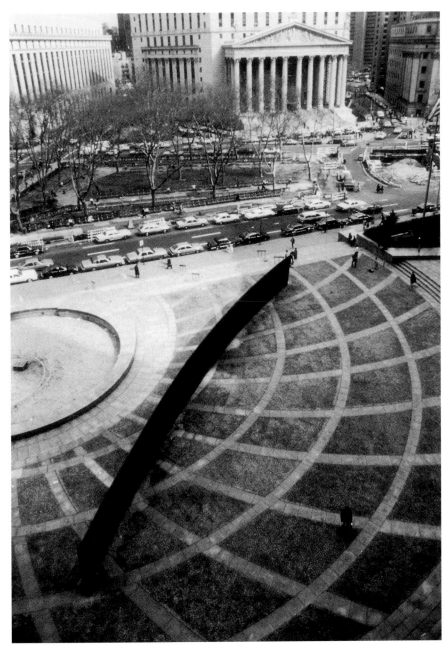

Richard Serra, *Tilted Arc*, Federal Plaza, New York City, 1989

row house became the focus of an intense public controversy, spurred by ambitious local politicians and tabloid animosity toward contemporary art. Here was a public sculpture which shifted our perception of the familiar and the quotidian, standing boldly between us and architecture. Its antecedent was Gordon Matta-Clark's *Splitting: Four Corners* (1974), where the artist made two straight parallel cuts through the center of a typical family house. Whiteread had replaced Matta-Clark's suburban Englewood, New Jersey with

East-End London but the effect was equally radical. She shattered the stability of the domestic container and rendered architecture as a function of art.

House performed a hierarchical reversal of art over architecture which most famously occurred with Richard Serra's *Tilted Arc* (1989) on New York's Federal Plaza. The *Tilted Arc* controversy, which resulted in the work's ultimate removal, drove public art administrators towards an ideology of "integrated," "site-specific," and, ultimately, "community-based" projects that valorized process over production. *House,* however, was an object, a sculpture which demanded to be considered on its own terms. Serra's art had finally been subordinated by its environment; Whiteread met the same public vehemence with defiance, refusing to relocate her work.

In contrast to John Stuart Mill's famous "harm principle" by which an agent's freedom in public life is limited only to the extent to which she or he might physically harm another person, for the artist working in the public sphere the purview is considerably reduced. Whiteread, with the bitter controversy of *House* not yet buried, was reluctant to embark upon another public project.

The Public Art Fund's invitation was open-ended, without site or budget. Whiteread could propose anything. Her first research trip to New York in the fall of 1994 began with a walking tour of prominent sites associated with temporary sculpture exhibitions from midtown to lower Manhattan: the southeast corner of Central Park; Park Avenue's Seagram Plaza; the narrow wedge-shaped traffic island in front of the Flatiron Building. All these public sites provide pedestals for public art but none of them interested her. Always

Gordon Matta-Clark, *Splitting: Four Corners,* 1974

on foot, she criss-crossed the city from Tribeca to the Lower East Side, looking at side streets and vacant lots, the spaces between tenements, potholes and garbage piles. The idea of adding yet another element to the visual cacophony of New York's streets became increasingly problematic to her.

I suggested we go over to Brooklyn under the Manhattan Bridge, an area now teeming with artists' studios that had originally attracted Vito Acconci as "the kind of place where bodies get dropped off." On the Brooklyn side of the East River we stood looking back at the city. As Whiteread's guide, I felt as if we had come to the end of the line. From this vantage point, the skyline dotted with industrial rooftops draws the eye above street level; two enormous water tanks solidly command their metal posts adjacent to the subway line carrying trains over the Manhattan Bridge. Like many visitors to New York, Whiteread commented upon the unique quality of New York water towers, those anonymous vernacular forms raised precariously on their steel perches, their presence ubiquitous yet seeming obsolescent.

About two weeks later I got a call from Whiteread. She proposed to cast a water tank in translucent resin, to be situated in the rooftops on a steel frame dunnage. Seemingly simple, Whiteread's proposal presented a radical departure from existing public sculpture. Perched up high, where many New Yorkers landscape private arcadian retreats from urban life, the sculpture would be visible yet inaccessible from the street. Being a life-sized cast, although the work would be massive, it would reverse the spectacular out-sizing of so much public sculpture from Claes Oldenburg onwards. Whiteread's approach to working in an architectural environment is to reduce scale just slightly below a 1:1 correspondence, a result of the interior casting method during which shrinkage occurs. Finally, she asked that the sculpture not be lit at night but rather allowed to disappear with the onset of dusk. We began our investigation.

The anonymity of the water tower's architecture is matched by the scarcity of documentation and the secrecy with which the city's tank manufacturers guard their vernacular craft. Early research turned up little beyond Bernd and Hilla Becher's description, "Functional Aspects of Water Towers," in their classic photographic study of the subject:

> The water tower is a part of the complex system by which water
> is collected and distributed. Consisting of a water tank and
> a tower-like substructure, it fulfills two purposes at the same
> time: storage and the maintenance of pressure.

How high a water tower must be depends on how far the water it stores must be delivered. The size of the tank is determined by the amount of water that must be made available at times of peak demand, by daily variations in consumption, and by consideration of emergencies such as fires and pump failures.

For over a year our search for potential water towers was like trainspotting, with positive sightings as close as Union Square and as far afield as the South Bronx and Williamsburg alongside the Brooklyn Queens Expressway. A magnificent one in Chelsea, sighted from Dan Graham's installation on the Dia Center rooftop, became a possibility for the project only to slip from our reach due to the expeditious redevelopment of the area. Seemingly derelict water tanks with gaping roofs turned out to be functioning suppliers of warehouse sprinkler systems. Wherever we went, new water towers appeared on the skyline but none were available for Whiteread's use.

During the same period, technical research was hardly producing more positive results. Finding an engineer with the appropriate expertise and willingness to calculate the various stress factors of producing a resin tank was proving difficult as none was willing to forfeit insurance liability on such untested ground. Of the limited number of manufacturers who produce clear resin, most cautioned against its use on such an ambitious scale and none would guarantee its success. Then an additional problem began to interfere with the project's development. Having been selected by an international jury for the commission of a holocaust memorial in Vienna, Whiteread was now in the eye of a political storm that made the realization of her winning proposal seem increasingly unlikely. During this period, she shuttled between London, Vienna, and New York with mounting frustration.

Although the rhetoric of public art is so often couched in communitarian language, the experience of making an artist's work happen in public brings one to a more atomistic view of society. Collaboration takes place less between artist and the "community" (however defined) than among the individuals who join the common cause. And, as with all atomistic theories, chance is the critical factor.

In the summer of 1996 we met Richard Silver, Director of the American Pipe and Tank Company. Unlike the tank fabricators we had met previously, Silver embraced the project, volunteering to find suitable towers and to provide the wooden tank from which the work would be cast. At the same time, Charles Hickok, a professional model maker who had recently

left the aerospace industry in California, was brought in to assist Whiteread with the technical realization of the casting process. For Whiteread, the imperative remained to cast the tank in a translucent glass-like resin so clear that on a dull cloudy day it would almost disappear and at night it would become invisible. The antithesis of *House* with its brute physical presence, *Water Tower* was intended as an ephemeral ghost-like figure. Throughout *House*'s brief existence, Whiteread complained that she could never visit it without finding it busy with people, even late at night. *Water Tower* should be a solitary and silent structure unperturbed by the street below, not so much a sculpture on the skyline as part of the sky itself.

Hickok identified Clear Cast 2000, manufactured by BJB Enterprises in Tustin, California, as the resin to be used. While nothing on the scale of a water tank had ever been created in this material, the cast of a larger-than-life Native American hunter did exist at the Foxwoods Casino in northern Connecticut. We visited the Meshantucket Reservation and, in the unlikely setting of this kitsch emerald city, the resin for *Water Tower* was chosen. Whiteread then traveled with Hickok to Tustin to test the Clear Cast 2000.

In the meantime, Silver had found a vacant steel truss on the rooftop of 60 Grand Street in SoHo, and building owners Joe Bierne, Catherine Tice, and Ellen Weisbrood were willing to host the work. The engineer for the recent renovations at 60 Grand Street, Mark Hage, agreed to support the project and set to work calculating the specific gravity of resin, its strength and environmental durability, earthquake requirements (activated after the Los Angeles quake in 1994), and navigating New York City's byzantine building code restrictions. In the end, *Water Tower* required special laboratory tests (for the strength of cured resin and its fire resistance); a landmark district revocable consent permit (to allow a temporary installation in the Landmark District of SoHo); and a building code variance allowing the sculpture to be treated as a sign (there being no New York City Building Code permit for sculptures on rooftops and any structure on a roof requires a permit from the Building Department).

In May 1998, after almost four years, *Water Tower* was ready to cast. A cedar tank, chosen by Whiteread for its distinctive grain, was removed by the American Pipe and Tank Company from a rooftop at East 79th Street and, after a month of drying, reconstructed in a Chelsea warehouse. Now inverted, the inside of the tank was sealed with water-based polyeurathane paint, and coated with release agents PVA and PVC, which would allow the resin to take the form of the wood grain without bonding to its surface.

A fiberglass core, molded to create a uniform 4 in. cavity between it and the wooden tank, was then inserted and sealed in preparation for the resin pour. With the assistance of technicians from BJB, 9000 lb. of liquid resin were poured between core and tank over a period of twelve hours. At the end of this time, the volatility of the casting process—the constantly rising temperature (close to 200° C) and increasing physical pressures within the mold—ended in disaster. The fiberglass core of the mold severely cracked causing resin to pool and solidify in the base of the structure.

From the very beginning this speculative project, the budget of which allowed only for a single casting, was a risky proposition. Now faced with the very real possibility of failure, for three weeks fifteen volunteers chipped and chiseled the excess resin from the core. This laborious and toxic process was constantly threatened by the uncertainty of success. But it did work. At the end of May the completed hollow resin tank, polished on the interior, was right-sided and affixed to its cast base.

Finally completed on the morning of June 7, the tank traveled on a flatbed truck down the West Side Highway to Canal Street. Like the circus arriving in town, crowds gathered at the bottom of West Broadway to meet the water tank. After maneuvering the tank into a customized sling, a 440 ton crane lifted it seven stories up above street level to its steel base.

Unspectacular, yet mesmerizing in its ability to capture changing light, *Water Tower* challenges many of our assumptions about public art and its possibilities. As a work of public sculpture, it has eschewed the city's streets to find an unlikely space where those who seek it out will find it. It keeps its distance, deliberately removed from the viewer below. For those who visually stumble upon it, *Water Tower* the work is as anonymous and unassuming as the other water tanks whose rooftops it inhabits.

Uncanny in its strange beauty, *Water Tower* invites passersby to linger on the corner looking up. While undoubtedly present in physical terms, it has an ephemeral quality, constantly changing with the light conditions and all but disappearing at night. It resonates with—in fact, activates—its sur- rounding architecture, absorbing the city's history and materiality. Like the water towers of New York, with their awkward and precarious presence, Whiteread's sculpture provides a humanizing counterpoint to the encroaching commercialization of public space and public walls—an enigmatic vanishing point suggesting at once demise and resurrection.

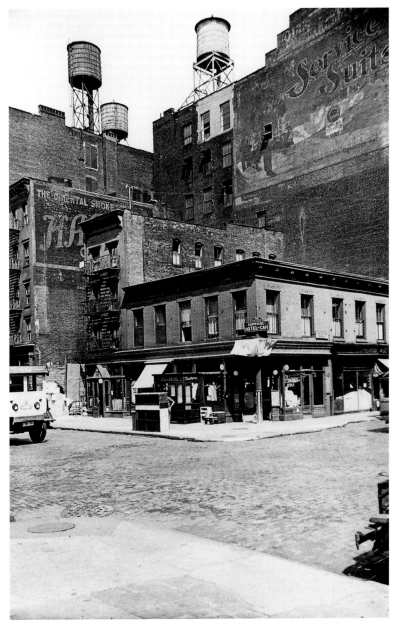

Original water tower at 60 Grand St., SoHo, c. 1940 New York Public Library Picture Collection

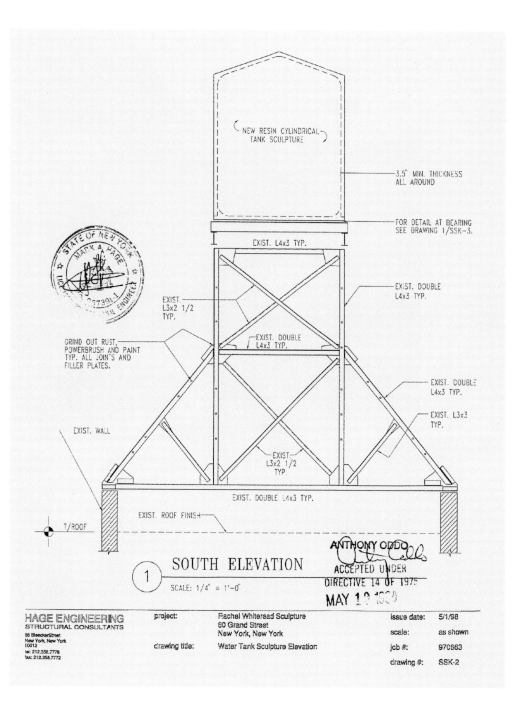

NEW RESIN CYLINDRICAL TANK SCULPTURE

3.5" MIN. THICKNESS ALL AROUND

FOR DETAIL AT BEARING SEE DRAWING 1/SSK-3.

EXIST. L4x3 TYP.

EXIST. DOUBLE L4x3 TYP.

EXIST. L3x2 1/2 TYP.

EXIST. DOUBLE L4x3 TYP.

GRIND OUT RUST, POWERBRUSH AND PAINT TYP. ALL JOIN'S AND FILLER PLATES.

EXIST. DOUBLE L4x3 TYP.

EXIST. L3x3 TYP.

EXIST. WALL

EXIST. L3x2 1/2 TYP.

EXIST. DOUBLE L4x3 TYP.

EXIST. ROOF FINISH

T/ROOF

SOUTH ELEVATION

① SCALE: 1/4" = 1'-0"

ANTHONY ODDO
ACCEPTED UNDER
DIRECTIVE 14 OF 1975
MAY 1 9 199?

HAGE ENGINEERING
STRUCTURAL CONSULTANTS
85 Bleecker Street
New York, New York
10012
tel: 212.358.7778
fax: 212.358.7772

project: Rachel Whiteread Sculpture
60 Grand Street
New York, New York

drawing title: Water Tank Sculpture Elevation

issue date: 5/1/98
scale: as shown
job #: 970563
drawing #: SSK-2

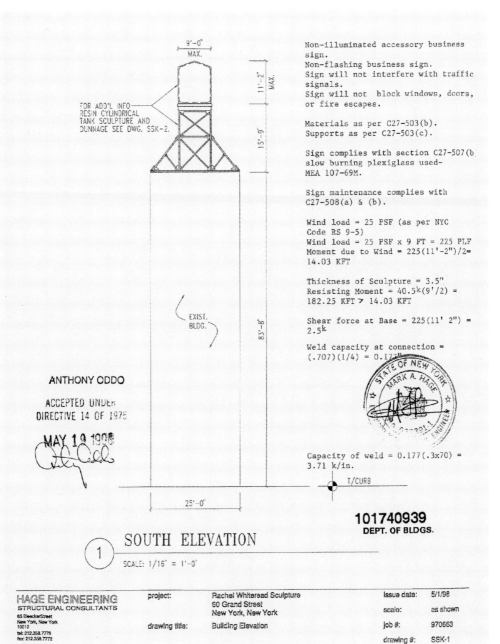

9'-0" MAX.

11'-2" MAX.

15'-9"

83'-8"

FOR ADD'L INFO
RESIN CYLINDRICAL
TANK SCULPTURE AND
DUNNAGE SEE DWG. SSK-2.

EXIST.
BLDG.

ANTHONY ODDO

ACCEPTED UNDER
DIRECTIVE 14 OF 1975

MAY 19 1998

25'-0"

Non-illuminated accessory business
sign.
Non-flashing business sign.
Sign will not interfere with traffic
signals.
Sign will not block windows, doors,
or fire escapes.

Materials as per C27-503(b).
Supports as per C27-503(c).

Sign complies with section C27-507(b
slow burning plexiglass used-
MEA 107-69M.

Sign maintenance complies with
C27-508(a) & (b).

Wind load = 25 PSF (as per NYC
Code RS 9-5)
Wind load = 25 PSF x 9 FT = 225 PLF
Moment due to Wind = 225(11'-2")/2=
14.03 KFT

Thickness of Sculpture = 3.5"
Resisting Moment = $40.5^k(9'/2)$ =
182.25 KFT > 14.03 KFT

Shear force at Base = 225(11' 2") =
2.5^k

Weld capacity at connection =
(.707)(1/4) = 0.17?"

Capacity of weld = 0.177(.3x70) =
3.71 k/in.

T/CURB

101740939
DEPT. OF BLDGS.

① SOUTH ELEVATION
SCALE: 1/16' = 1'-0"

HAGE ENGINEERING
STRUCTURAL CONSULTANTS
65 Bleecker Street
New York, New York
10012
tel: 212.358.7778
fax: 212.358.7772

project:	Rachel Whitbread Sculpture 60 Grand Street New York, New York	issue date:	5/1/98
drawing title:	Building Elevation	scale:	as shown
		job #:	970663
		drawing #:	SSK-1

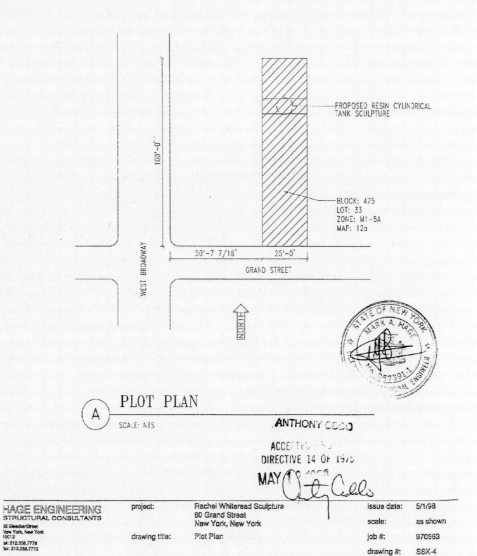

—PROPOSED RESIN CYLINDRICAL
 TANK SCULPTURE

100'-0"

BLOCK: 475
LOT: 33
ZONE: M1-5A
MAP: 12a

WEST BROADWAY

50'-7 7/16" 25'-0"

GRAND STREET

NORTH

(A) PLOT PLAN

SCALE: NTS

ANTHONY ODDO

ACCEPTED
DIRECTIVE 14 OF 1975

MAY

HAGE ENGINEERING STRUCTURAL CONSULTANTS 55 Bleecker Street New York, New York 10012 tel: 212.358.7778 fax: 212.358.7772	project:	Rachel Whiteread Sculpture 60 Grand Street New York, New York	issue date:	5/1/98
			scale:	as shown
	drawing title:	Plot Plan	job #:	970663
			drawing #:	SSK-4

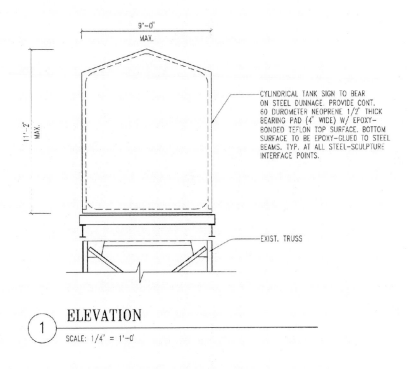

9'-0"
MAX.

11'-2"
MAX.

CYLINDRICAL TANK SIGN TO BEAR
ON STEEL DUNNAGE. PROVIDE CONT.
60 DUROMETER NEOPRENE 1/2" THICK
BEARING PAD (4" WIDE) W/ EPOXY-
BONDED TEFLON TOP SURFACE. BOTTOM
SURFACE TO BE EPOXY-GLUED TO STEEL
BEAMS. TYP. AT ALL STEEL-SCULPTURE
INTERFACE POINTS.

EXIST. TRUSS

ELEVATION

1

SCALE: 1/4" = 1'-0'

HAGE ENGINEERING	project:	Rachel Whiteread Sculpture	issue date:	3/18/98
STRUCTURAL CONSULTANTS		New York, New York	scale:	as shown
65 Bleecker Street New York, New York 10012 tel: 212.358.7778 fax: 212.358.7772	drawing title:	Elevation	job #:	970663
			drawing #:	SSK-1

WATER TOWER

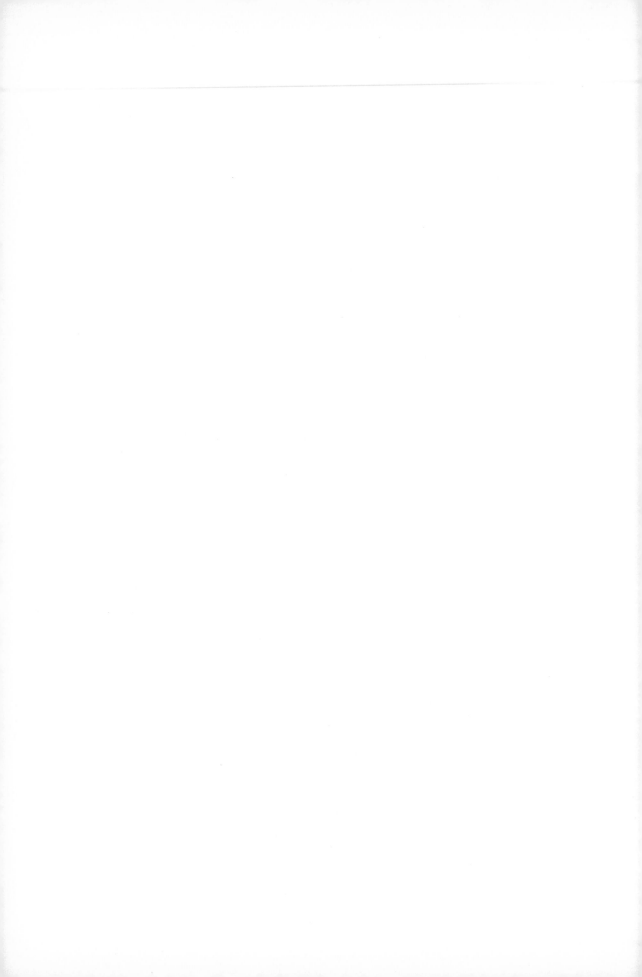

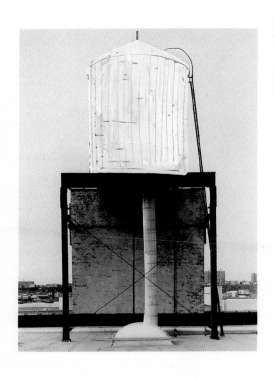

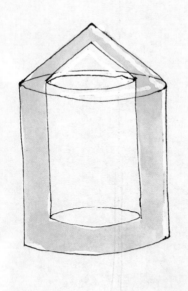

Water Tower to be cast off site,
then replaced and bolted into position

<u>P·A·F·</u>

Tom Eccles — Engineer looked at it
Model made - 10" tall with a conical to
Funding for photos.
Already raised £100,000
Tests to be made.

Patricia Arden -

The site finally chosen in Feb 97 after 2½ years of discussion: West Broadway.

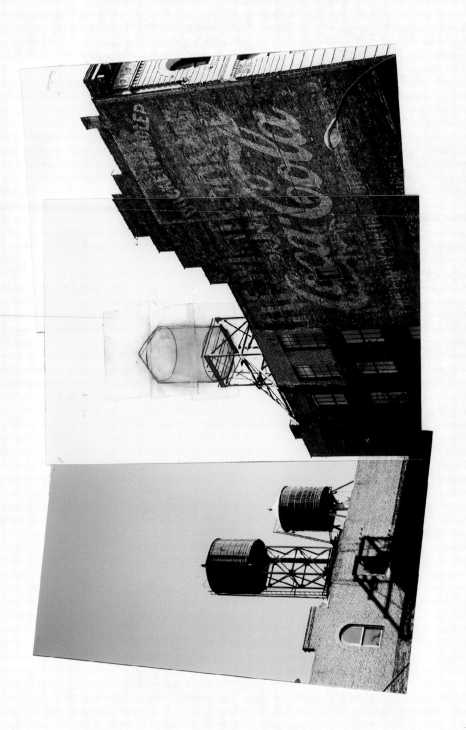

A

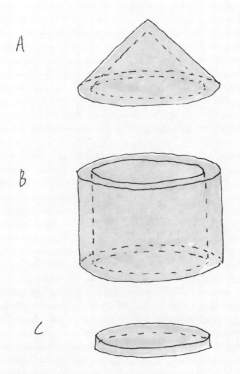

B

C

CAST IN THREE SECTIONS.
THEN FILLED WITH GLYCERINE, OR CLEAR LIQUID (STABLE)

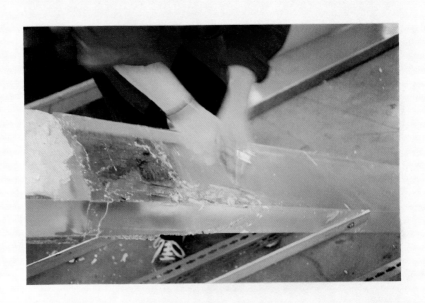

EXPERIMENT WITH OJB WC 783 A/B.

WHEN POURING THE MATERIAL INTO THE SILICONE (TIN BASED OLD MOULD)
NO POST CURING WAS NEEDED, A LOT OF HEAT GENERATED.

ACRYLIC BOX STILL VISIBLE, NO MORE THE 4cm " OF MATERIAL
AROUND THE ACRYLIC BOX.

/ VERY VISIBLE IF MATERIAL IS POLISHED

) MAYBE CAN USE ACRYLIC WITH SAME REFRACTIVE INDEX.
 (THE EDGES ARE ESPECIALLY VISIBLE)

i) POSSIBLE MATERIAL USED FOR FILL UP SAME REFRACTIVE INDEX
 WHICH IS 1.36.

ii) IF THERE ARE ANY POLISHED AREAS ON THE SURFACE
 ALL INTERNAL PROBLEMS BECOME MORE OBVIOUS.

iii) THERE WAS EXPANSION OR 3 or 4 mm ON A BOX
 WITH MEASUREMENTS OF :

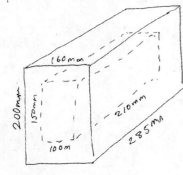

ix) IF THE WATER TOWER HAD AN INTERNAL STRUCTURE
 THAT WAS REMOVABLE , WOULDN'T HAVE THESE PROBLEMS.

I THINK NEEDS TO BE FILLED WITH SOMETHING
THAT HAS THE SAME REFRACTIVE INDEX. 1.36

(CAN BE FOUND IN reference bk - Tables of refractive
 indices

 (Kaye & Labery?)

(X) PROBLEM WITH CASTING WITH THE CORE / PRESSURES.

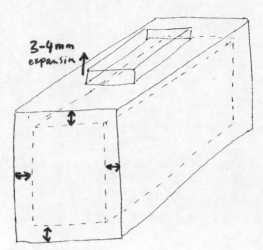

3-4mm
expansion ↑

DID NOT CRUSH THE BOX BUT INTERNAL EXPANSION NEED ALOT OF
GIVE SO STRUCTURE DOESN'T COLLAPSE.

✳ ACTUAL PIECE TO BE 3" → 4" THICK.
THIS ~~SYSTEM~~ EXPERIMENT BASED ON 1½".

<u>Advise on site whats happening?</u>

Is led Indian translucent.

In experiment was sent wrong mat. — should have
reduced catalyst.

ERALS:

PIECE to BE CAST AS ONE
CAST IN STUDIO AND HOISTED TO THE ROOF TOP.

FILLED WITH SOMETHING (LIQUID) TO GET RID OF UNEVENESS
IN REFRACTION.

TO SIT ON I BEAMS

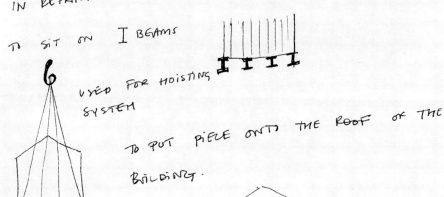

USED FOR HOISTING
SYSTEM

TO PUT PIECE ONTO THE ROOF OF THE

BUILDING.

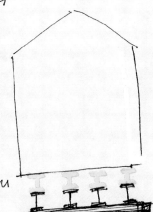

EXAGERATED VIEW BUT

BEAM TO SIT ON BEAM

✗ NO.

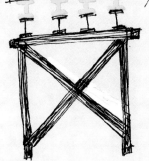

OR,

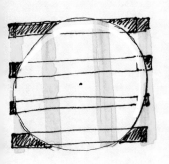

✱ RECOMMENDS A COMPLETELY REMOVABLE
SYSTEM ✱

TEXTURE

Made a clear decision with Chuck. that the piece need's to
be cast as one. MONOLITHICALLY.

Need, must, get the engineer MH to agree with this

Shear test needs to be done :—

?

Which is the break point when
when a material breaks when
an enormous amount of pressure
is evenly put on a material

FOXWOODS RESORT CASINO

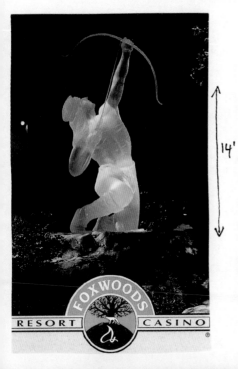

14'

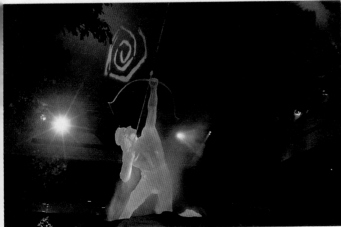

BJB

WATER CLEAR
URETHANE CASTING
RESIN.

FOURTEEN FOOT HIGH
CLEAR RESIN
NATIVE AMERICAN
INDIAN.

LARGEST PIECE
CAST IN THIS
 MATERIAL.

PRINT — PAF.

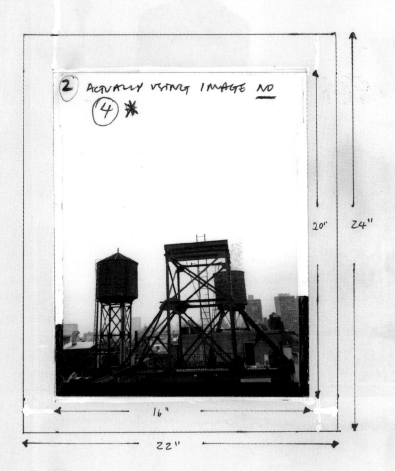

2 ACTUALLY USING IMAGE NO

4 ✳

20" 24"

16"

22"

SCALE 1:4 INCHES

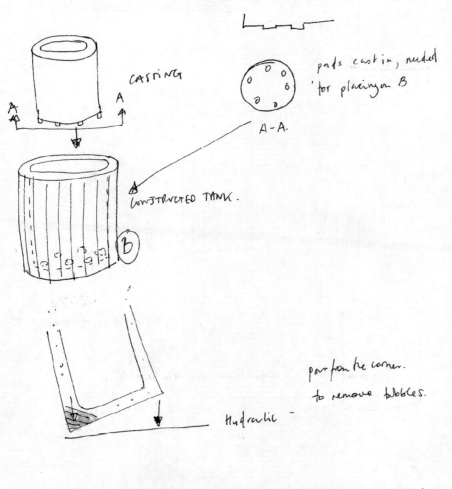

CASTING

A A

A A

A - A.

pads cast in, needed
for placing on B

CONSTRUCTED TANK.

B

Hydraulic

pour from the corner.
to remove bubbles.

COULD BE A PROBLEM WITH
BUBBLING

$\frac{1}{2}$" 3"

U.V NORMAL.

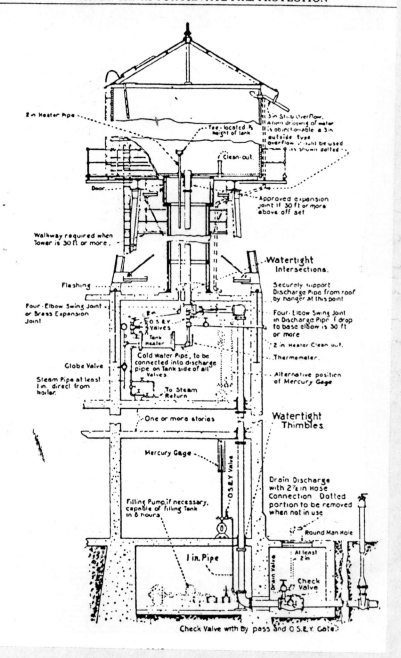

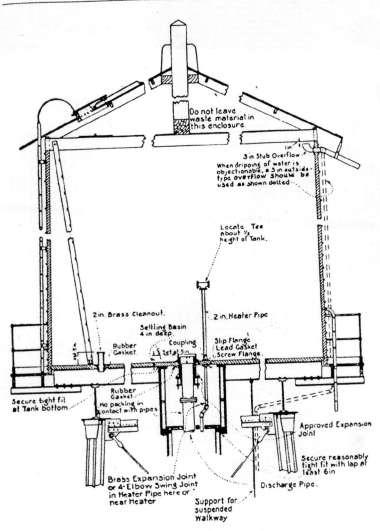

Do not leave
waste material in
this enclosure.

3 in Stub Overflow.
When dripping of water is
objectionable, a 3 in outside-
type overflow should be
used as shown dotted

Locate Tee
about ⅓
height of Tank.

2in. Brass Cleanout.

2 in. Heater Pipe

Settling Basin
4 in deep.

Coupling

Slip Flange
Lead Gasket
Screw Flange

Rubber
Gasket

Rubber
Gasket
No packing in
contact with pipes

Secure tight fit
at Tank bottom

Approved Expansion
Joint

Secure reasonably
tight fit with lap at
least 6in

Brass Expansion Joint
or 4 Elbow Swing Joint
in Heater Pipe here or
near Heater

Support for
suspended
Walkway

Discharge Pipe.

For SI Units: 1 in. = 25.4mm; 1 ft = 0.3048m

Figure B-8-3. Typical Tower-Supported Wood Tank.

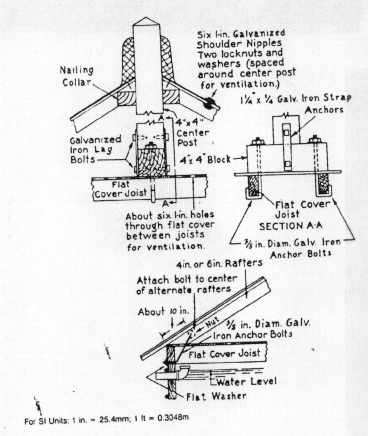

For SI Units: 1 in. = 25.4mm; 1 ft = 0.3048m

Figure B-4-1. Details of Tank Roof Construction.

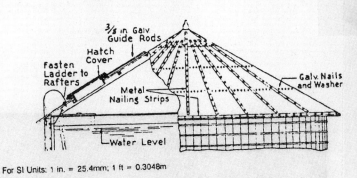

For SI Units: 1 in. = 25.4mm; 1 ft = 0.3048m

Figure B-4-2. Section of Conical Roof.

A

A

B

Sorting and setting out of the boards

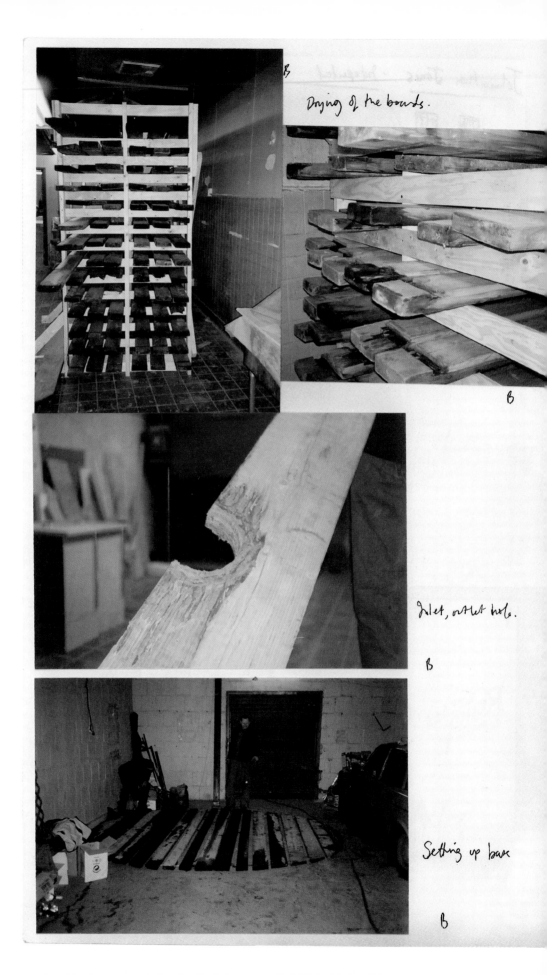

Drying of the boards.

B

Inlet, outlet hole.

B

Setting up base

B

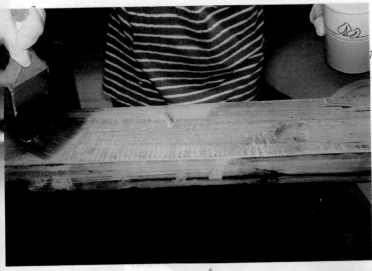

Board preparation

c

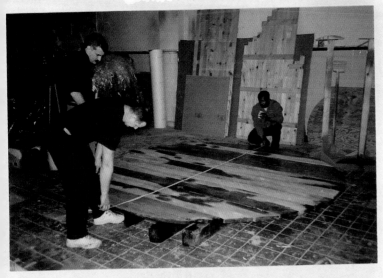

Setting up of base

c

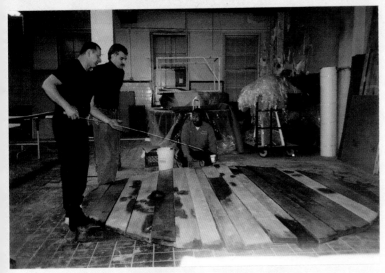

c

Chalk — 8 any — 12" Acrylic * Peter — other stuff. *
 Tank Mark — Chippy.

Run —
Glycerine & $1 gallon.
Ionised water + clear antifreeze.

How much in interior core fill? — in volume. TUSTIN — CALIFORNIA.
 26th FEB 1998.

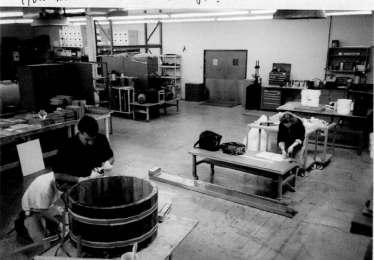

tank in progress.

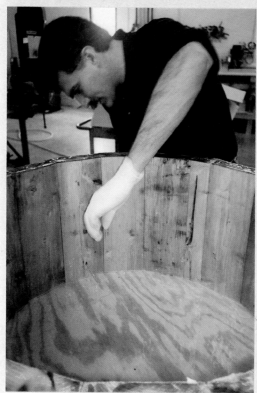

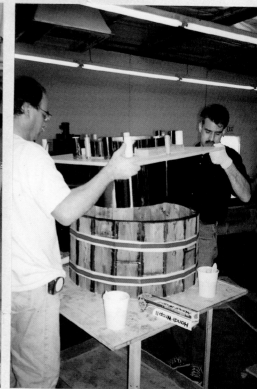

with first U.V coats BTB. Core in place.

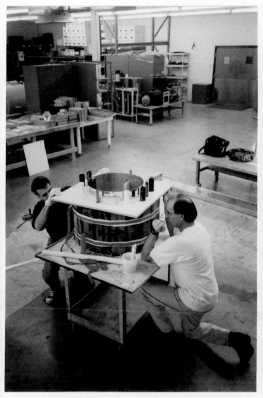

Core in place, fully sealed

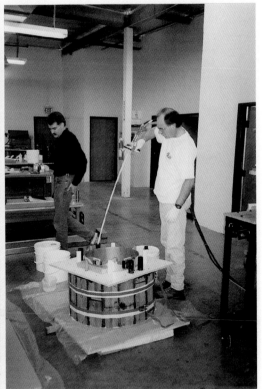

Fill of BJB

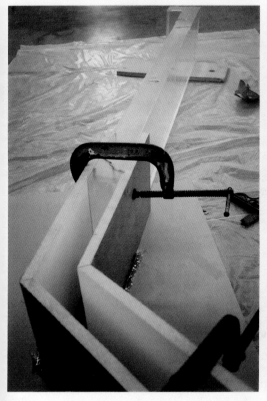

Plank test, cut, for refraction test

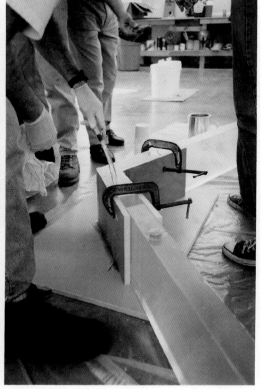

Plank test filled.

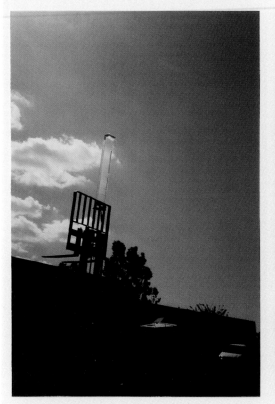 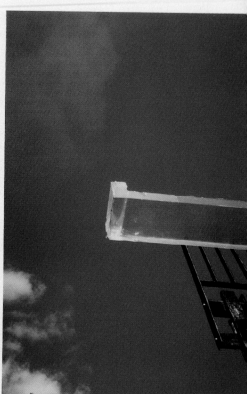

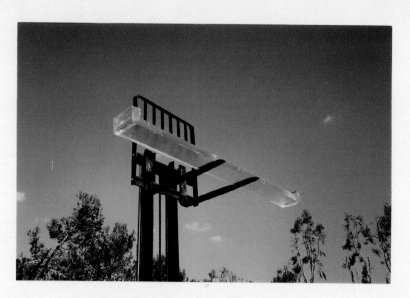

light tests — very good clarity but too
green.

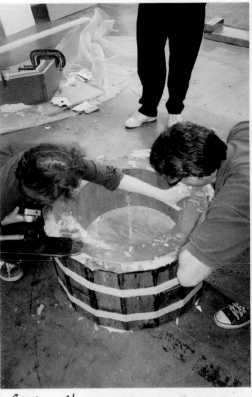

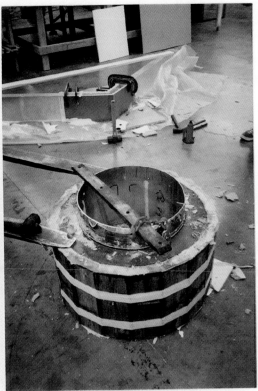

Good result.

Core stuck — bottle jacks needed to remove.

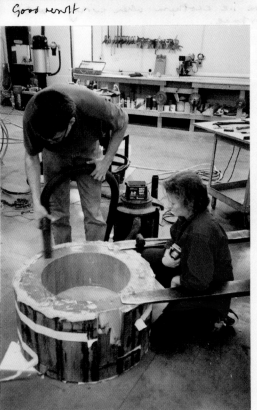

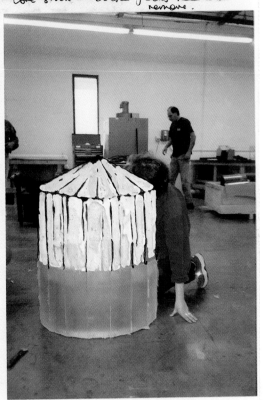

Part, problem with release agent.

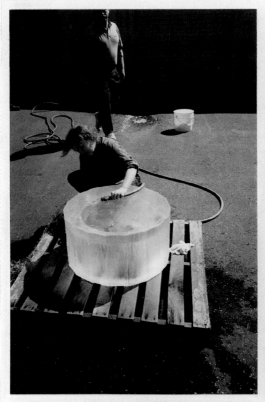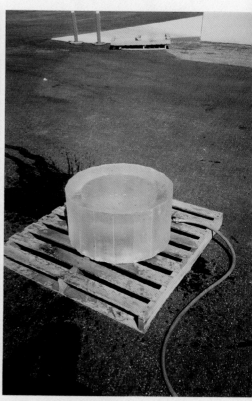

Release agent problem; temperature i.e exotherm when curing — welds
the release to the surface.

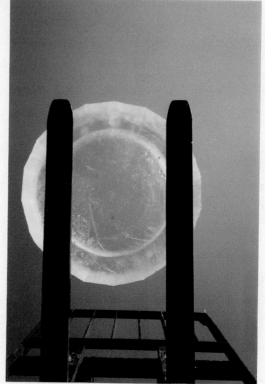

Core needs to be
rethought.
More of an organic
structure — to try
and eliminate the
line.
i.e. the clumsy vertical
and horizontals.

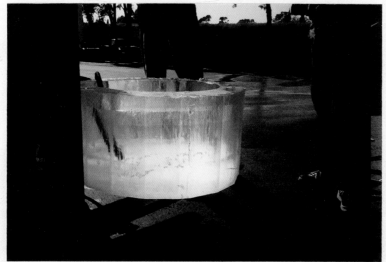

Filled with water, helps to eliminate the internal lines.

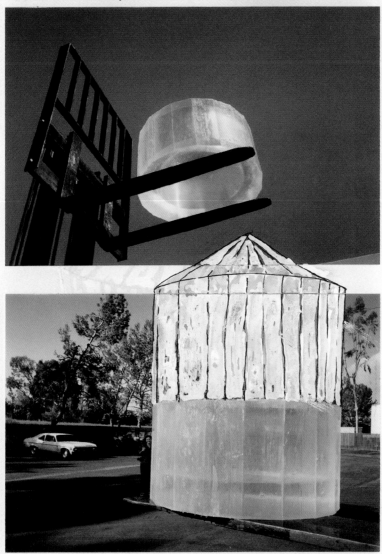

Fantastic to see what it does with the light.

Volume - INTERNAL

1,500 &: 4,500 GALLONS = 6,000 GA

BJB (POSSIBLE LIQUID)

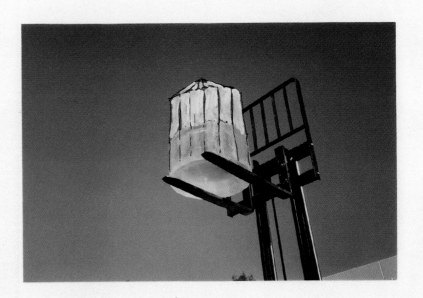

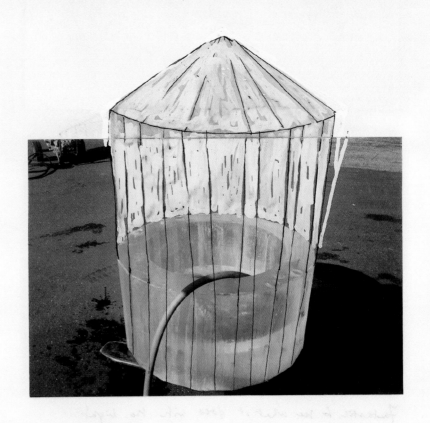

Publication. 3rd March 98.

Meet Louise - in London. ⟶ Louise discuss with Tom (NY)

So from there.

Neville on board - critical,
technical.

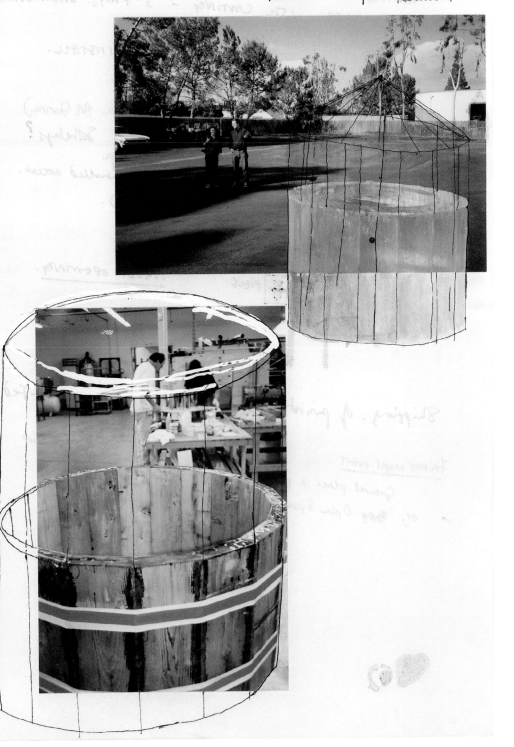

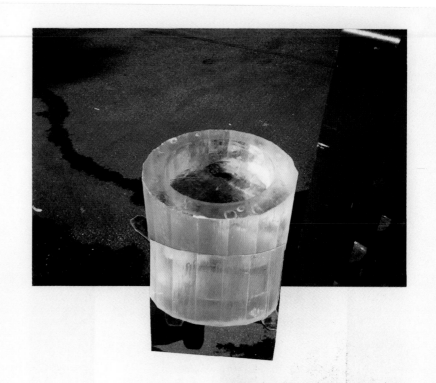

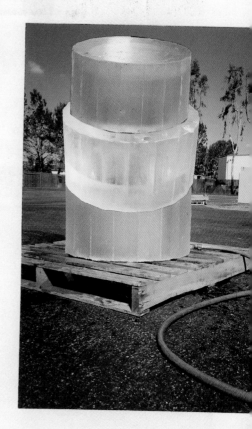

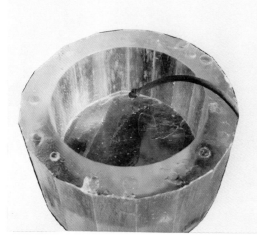

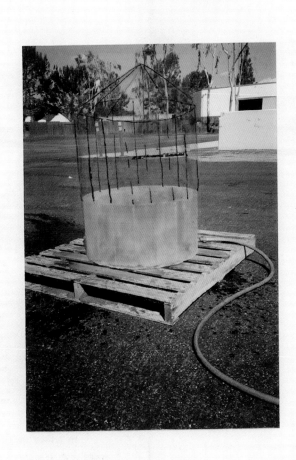

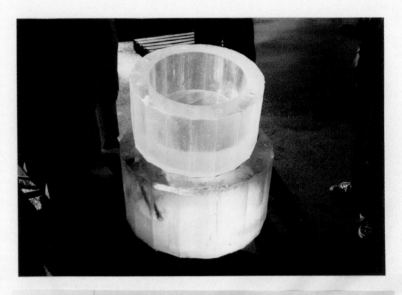

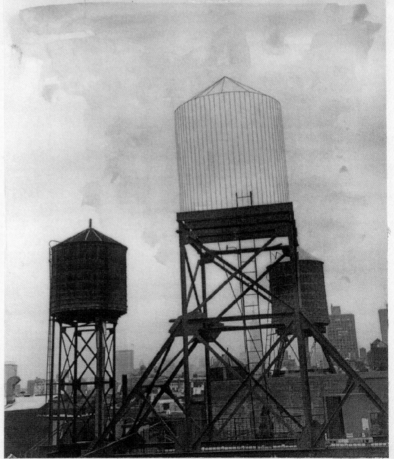

. 4. 98.

Rafters, now approx 1½" deep –
Roof to be made with my licence , cast in 14 sections
Need to figure out what happens at: 2 points.

. 7 ÷ 2 =

① where rafter meets centrally.

② where rafter meets at the edges:
 whether or not this plane gets filed off.

Other potential problem:
making the base.

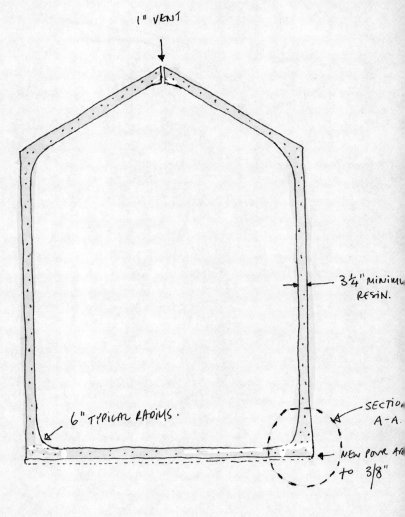

1" VENT

3¼" MINIMUM RESIN.

6" TYPICAL RADIUS.

SECTION A-A.

NEW POUR AREA to 3/8"

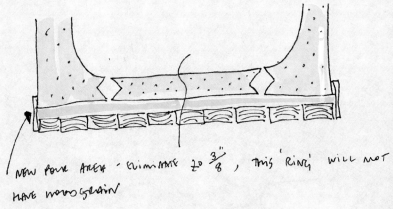

NEW POUR AREA - ELIMINATE TO 3/8", THIS 'RING' WILL NOT HAVE WOODGRAIN

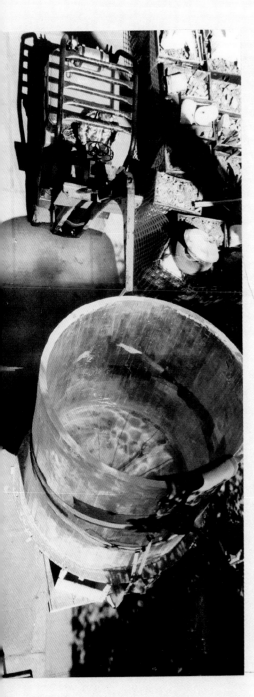

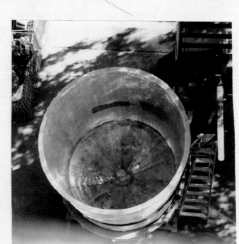

$210 - $15.80 - USA. Register.

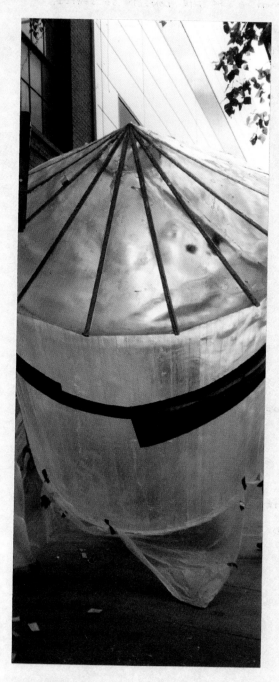

DECISION ON SEAMS CORRECT, EASILY LAID OUT

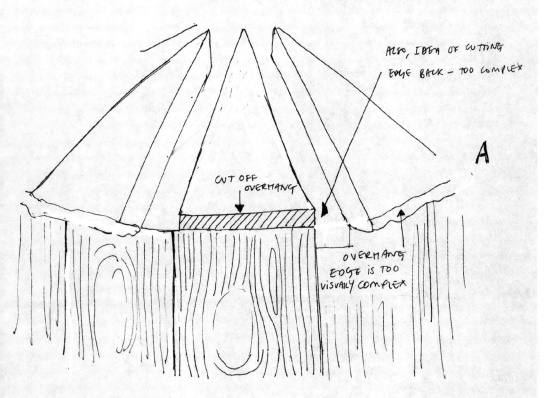

ALSO, IDEA OF CUTTING
EDGE BACK - TOO COMPLEX

A

CUT OFF
OVERHANG

OVERHANG
EDGE IS TOO
VISUALLY COMPLEX

DECISION TO BE MADE, WHETHER TO
USE A OR B, FEEL THAT A SOLUTION IS MORE APPROPRIATE -
THE CONSTRUCTION FEELS MORE HONEST AND CLOSER TO THE ORIGINAL.

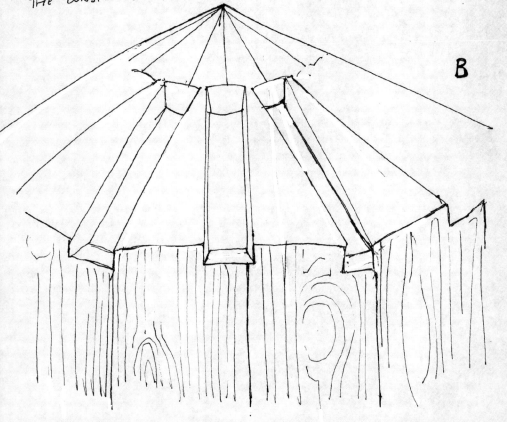

B

CORE FINALLY MADE FROM:
DIVINCELL, LAMINATED —
SUPPOSEDLY ABLE TO WITHSTAND
HIGH TEMPERATURES, COVERED
IN FIBRE GLASS.

SHOULD HAVE STAYED WITH
STAINLESS STEEL CORE!

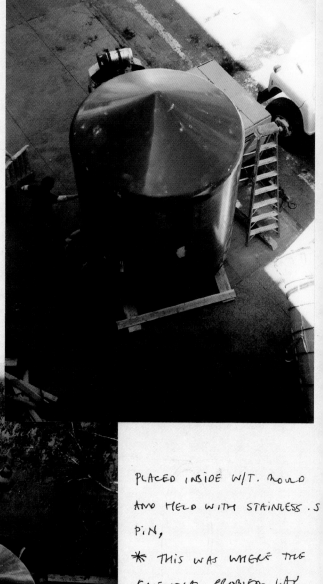

PLACED INSIDE W/T. MOULD
AND HELD WITH STAINLESS. S
PIN,
* THIS WAS WHERE THE
EVENTUAL PROBLEM LAY
THE PRESSURE + HEAT AT
THIS POINT WAS SIMPLY TOO
 MUCH.

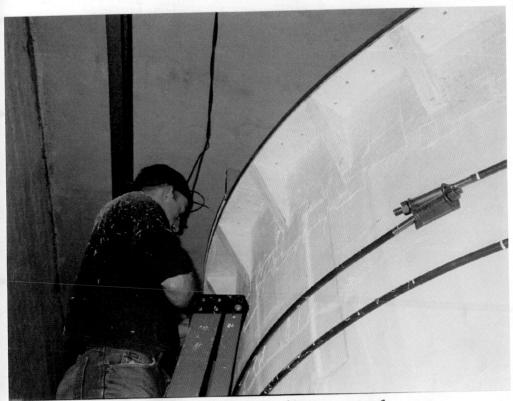

OUTSIDE OF TANK, EPOXIED, WITH STEEL BANDS + FLANGE.

PLACEMENT OF ROOF, TWO POURED GASKETS, TO STOP ANY LEAKAGE.

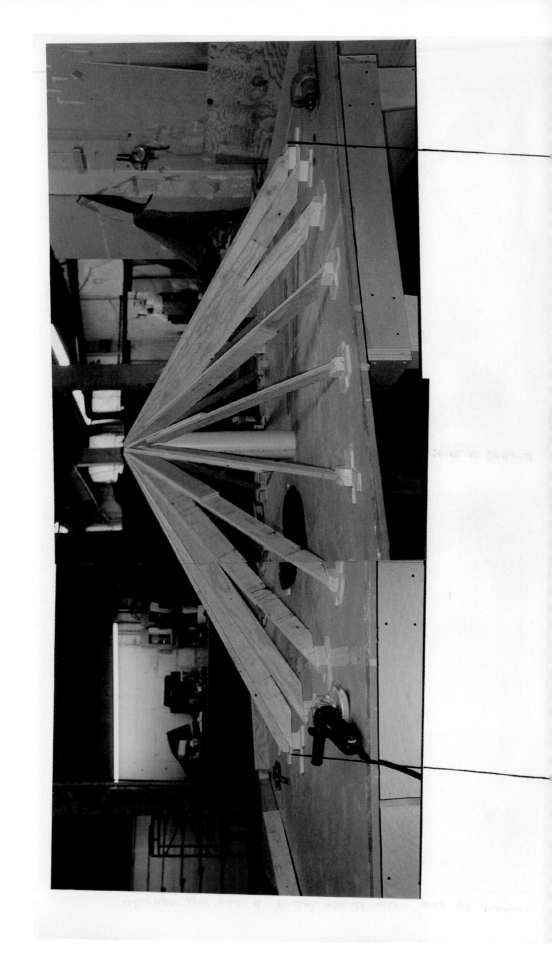

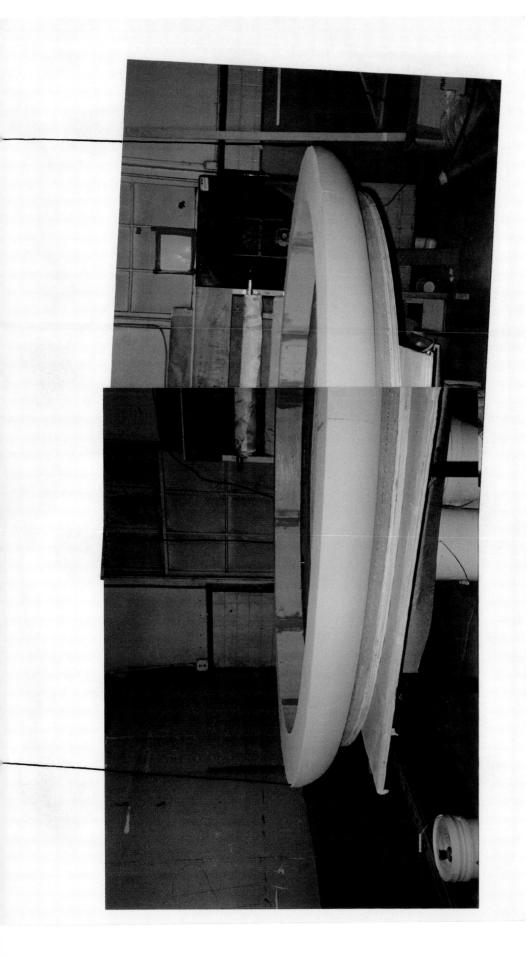

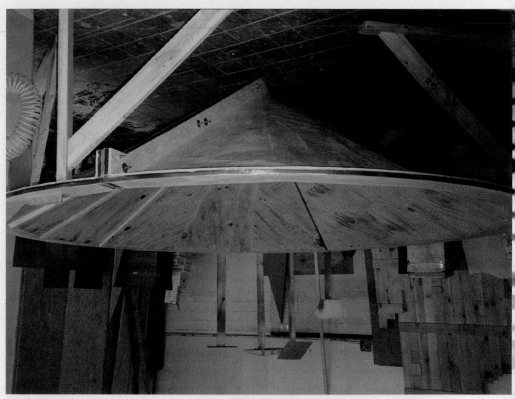

EPOXIED ROOF, IN 2 SECTIONS, JOINED AND BEAMS

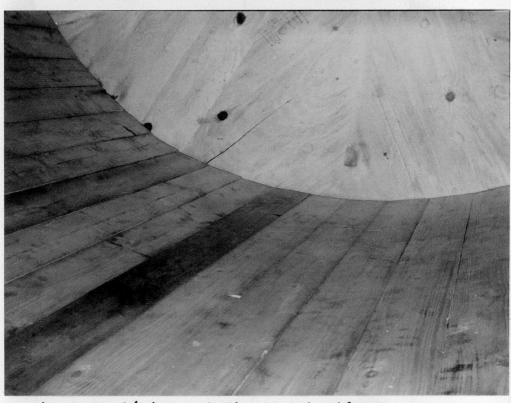

BEST POSITION FOR ROOF - AVERAGING THE OVERHANG.

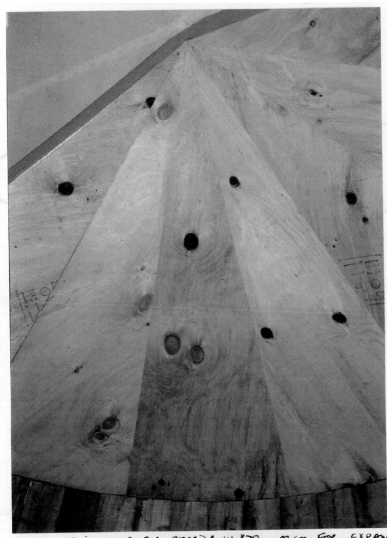

KNOT HOLES BECOME
PART OF CASTING.

ACRYLIC PIPES IN PLACE FOR POURING IN BJB — ALSO FOR EXPANSION

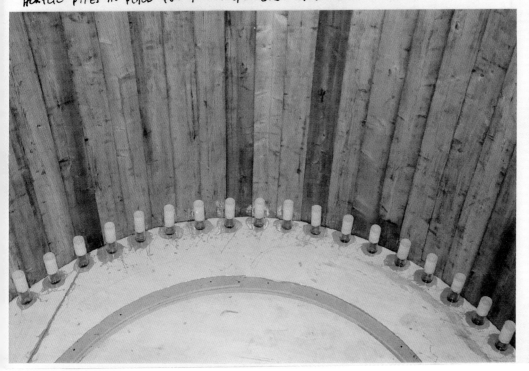

BIG F. TROUBLE!

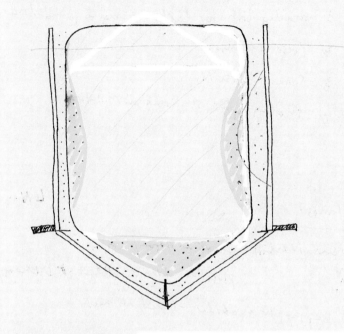

1. CUT OUT TOP TO SEE WHAT IS GOING ON FEEL WALLS.

2. GET INSIDE TANK,

3. GET IN MORE RESIN WITH A FASTER KICK. ie. 15 MINUTE GEL TIME.

4. INJECT EPOXY BETWEEN LAMINATE, (CORE). SHORE UP LAMINATE.

5. COULD MAKE THE PIECE 18" SHORTER.

WHAT WE DON'T KNOW!

① HOW MATERIAL HAS BLISTERED.

② ACTUAL HEIGHT OF MATERIAL ie. 18" SHORT, BUT ONLY
IN PARTS.

∴ WHAT HAPPENS TO THE SURFACE.

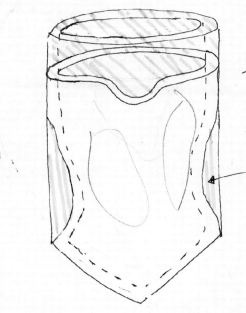

SEEMS TO BE DOING THIS.
BUT
IF THERE IS STILL A MEMBRANE
RESIN CAN BE INJECTED INTO
THE SURFACE.

— INJECT NEW RESIN.

③ WE DON'T KNOW IF THE U.V COAT HAS PULLED FROM
THE SURFACE.

THE PIECE COULD HAVE A "MEMORY" OF THE LAST
CAST SURFACE, COULD LIVE WITH.

· WAIT FOR IT TO COOL·

POSSIBLY PAINT ON UV STABLE MATERIAL AFTERWARDS AND
POST CURE. (MAYBE THAT WOULD HAPPEN OK ON THE ROOF)

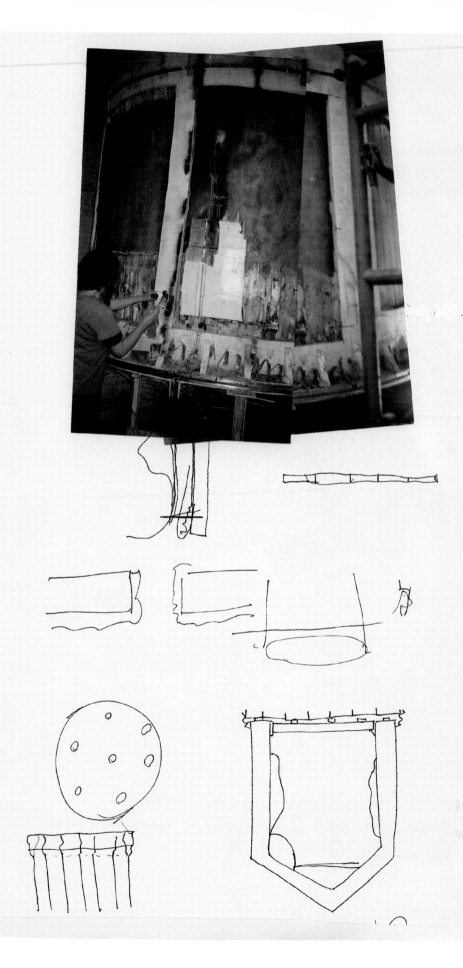

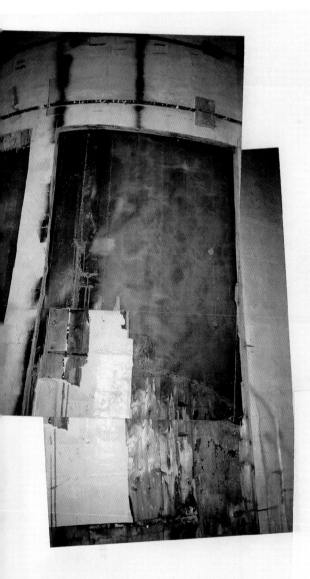

DAMAGED AREA TO FACE EAST.

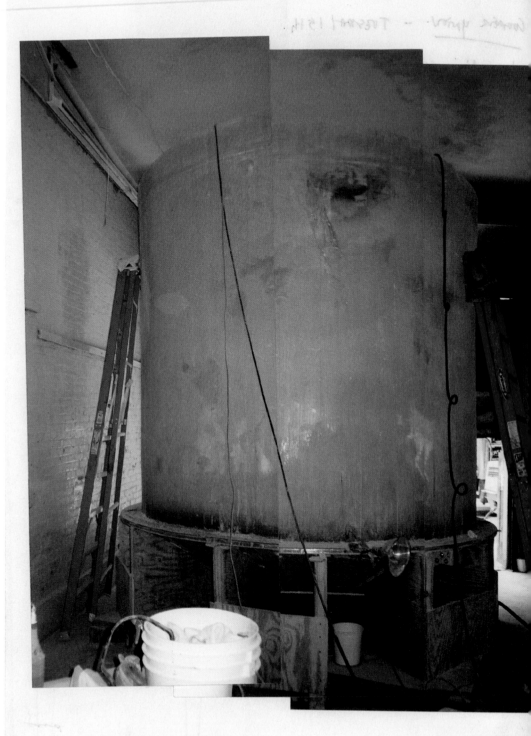

CLEAR ASSESSMENT OF DAMAGE,
CERTAINLY ABLE TO RESURECT.

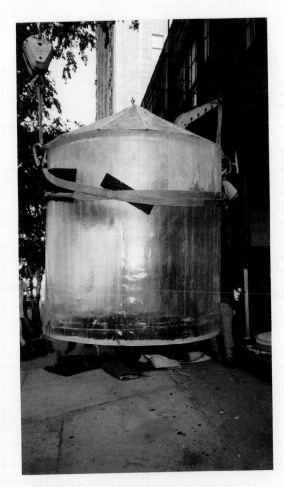

SIDE WITH MOST DAMAGE,
TO BE PAINTED IN 783. 4V
THIS SIDE TO FACE EAST.

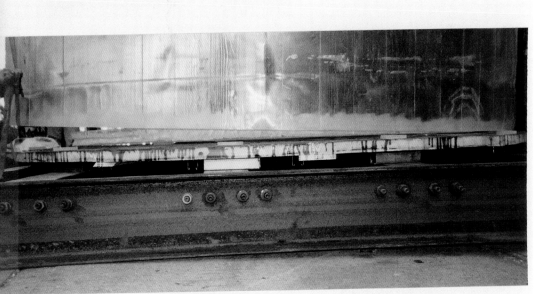

BASE TO BE POURED.

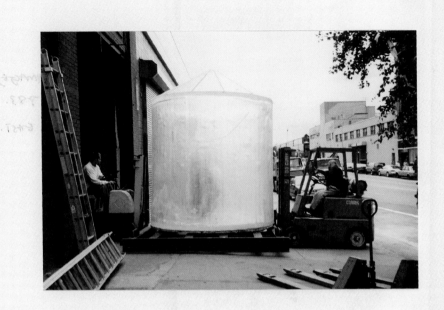

Ready for LIFT...

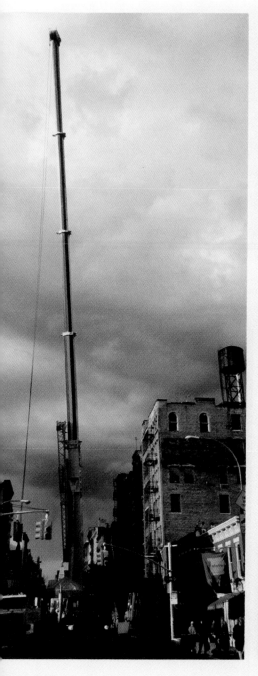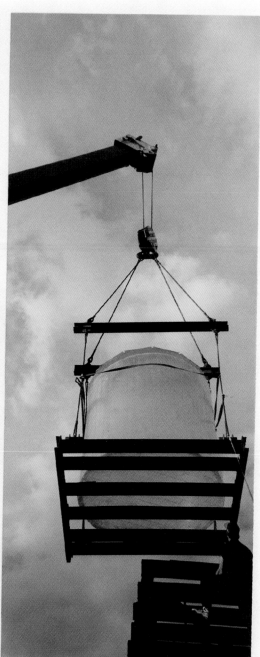

SITE... CRANED ON...

STREET

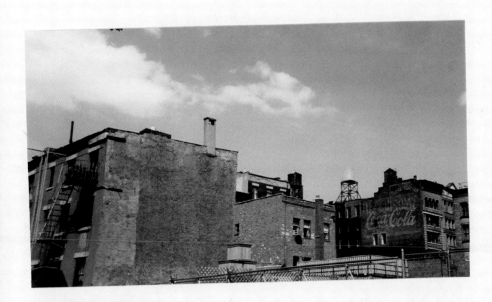

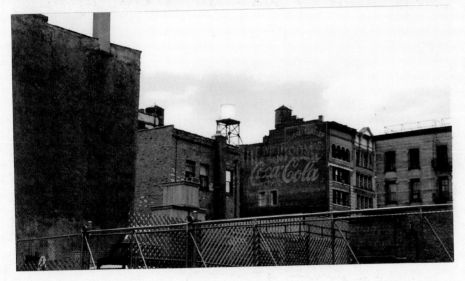

WORKED AS INTENDED.

① CLEAR IN BLUE SKY

② DISAPPEARING IN WHITE LIGHT

③ ALSO AT NIGHT, ALMOST NOT THERE.

④ RAIN? } TO BE PHOTOGRAPHED

⑤ SNOW? }

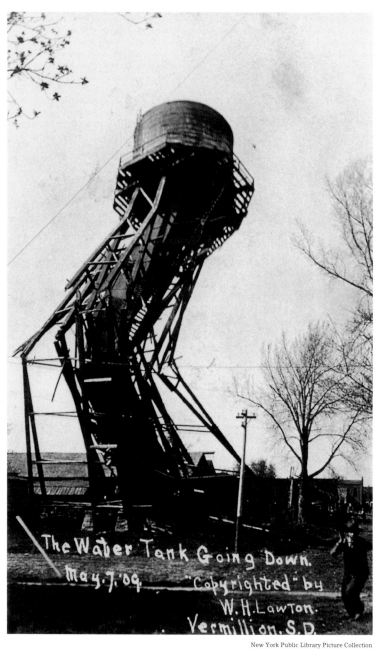

The Water Tank Going Down.
May. 7. 09. "Copyrighted" by
W. H. Lawton.
Vermillion, S. D.

CABIN IN THE SKY

The water tower is a primal element of New York City, proliferating among the tops of medium-sized buildings like mushrooms on the forest floor. Although omnipresent, and comforting in their omnipresence, water towers have nevertheless managed to avoid dull familiarity. You never quite cease to see them, unlike fireplugs and mailboxes which are camouflaged by repetition. Instead, with the passage of time, they seem somehow to grow increasingly unfamiliar. A little over a century ago, when water towers became fixtures of those ten- or twenty-storey buildings they crown, they might have lurked beneath notice as much as they planed above all of Manhattan; today they make their presence felt with more insistence than they did even twenty years ago.

That is because the water tower is a vestige of the rustic. It is not literally a holdover. Water towers as we know them today started going up around the same time as the last bits of rural Manhattan were being leveled and paved. They simply represented an engineering solution to the problem of water pressure in buildings of the transitional era between the age of the tenement and that of the skyscraper. Their shape and rough-hewn wooden construction likewise responded to necessity; modern technology has scarcely improved upon the adaptability of wood to climate and moisture. The stubbornness of this fact, though, matches the obstinacy of weather itself in resisting the hubris of progress. The water tower, a strictly functional item, intrudes upon turn-of-the-millennium Manhattan with the allure of a backwoodsman at a cocktail party. On an island with no natural coastline remaining in its southern three quarters, and only the barest traces of its original topography, it is possible to look out of one's window and see a profusion of objects that have an appearance halfway between a yurt and an outhouse.

The neighborhood with which water towers are most closely identified is SoHo. There are clusters of them on the Upper West Side and pockets remaining in Midtown, although the older and smaller constructions which host water towers in that area are being felled at an alarming rate. The loft buildings of SoHo, however, are almost all the right size and age for water towers, and not incidentally many of them are protected by landmarks legis-

lation. Artists began populating the neighborhood in the early 1960s, when it seemed to be facing immediate doom. The planning czar Robert Moses, then in his later capacity as "Coordinator of Federal-State-City Arterial Projects," was acquiring property along the Broome Street corridor in anticipation of his proposed Lower Manhattan Expressway. This road, one of three transversal highways linking the Hudson and East Rivers that Moses had been pushing since about 1941, was apparently set for immediate construction in 1965. Somehow, though, at the eleventh hour, municipal powers from the Mayor's office to *The New York Times* experienced a collective change of heart concerning vast public-works projects. The greatest concentration of cast-iron architecture in the country was thus spared the fate of Penn Station and the numerous other victims of Moses's *folie de grandeur*. A decade ensued during which SoHo was a quiet place. Shops and bars were few and far between; some of the loft buildings were still occupied by jobbers in agricultural machinery and importers of cork products; lower Broadway was lined with the showrooms and offices of wholesale hatters and manufacturers of uniforms. The cobbled streets contributed to a slightly forlorn nineteenth-century air, with a distinct if by then nonspecific port-city breeze blowing through it.

The water tower was of a piece with this atmosphere, with the hollow sidewalks and the wooden skids and the iron loading docks. It was a time when artists were briefly given a free run through the boneyard of industry, allowed to play with stuff that had recently slid off the commodity shelf. The art that emerged from the milieu partook of its material texture: the sculptures of Robert Morris and Dennis Oppenheim at the time, for example, often give the impression of having been assembled on site from gathered trade remnants and random cast-offs. It is not hard to imagine the water tower figuring in work of the era—segmented by Gordon Matta-Clark, or fragmentarily alluded to by Alice Aycock or Jackie Ferrara, or halfway destroyed by Robert Smithson. That it failed to cut a figure is little more than sheer happenstance, perhaps a measure of overfamiliarity. There was so much textural competition, so much rough-hewn wood and burlap in torn sheets and stencil lettering and fractured masonry and heaps of rust. The water tower was an ensemble player, a face in the crowd.

Then the real-estate market caught fire, beginning in the late 1970s, and SoHo was progressively gut-rehabbed, sandblasted, burnished to a fine sheen. Artists were shown the door, and after an interval many galleries followed. Where a scant twenty years ago the place alluded to an industrial past

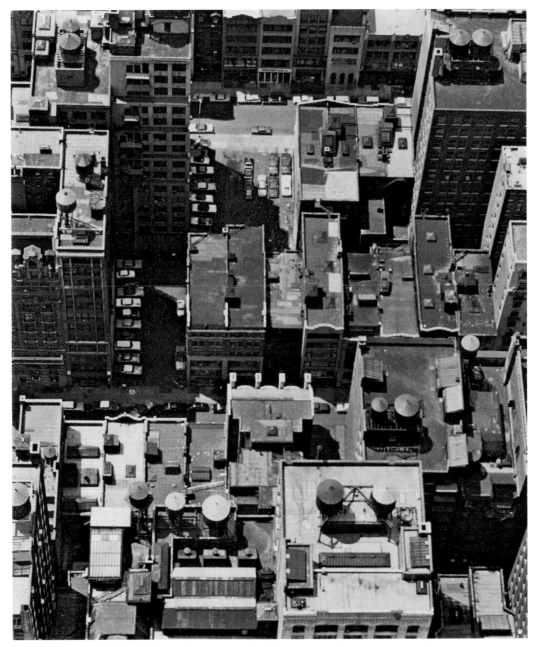

New York City, c. 1970

that survived only in relic form, now the same applies increasingly to art. The odd loading platform aside, there is little trace remaining of industry. It is barely even a memory. The way that lofts once retained clues to their former uses—an odor of spices or a winch high up in a corner or a pile of enigmatic machine parts—so interiors are now merely reminiscent of exhibition spaces, while making it clear they have no truck with the non-paying public. What the high-end residential and middling retail district SoHo has become makes

perfect sense in view of current economic conditions but seems wildly un-
likely from the perspective of even the recent past. In this context the water
tower looks all the more impressive—to put it in the cant of the 1970s, it is
a survivor, and a tough customer at that. That cast iron should have weathered
so many changes is hardly surprising, but for rough unpainted wood to have
managed to do the same appears an amazing feat of will.

Water towers, then, are a bit like those people who when young were
barely noticed, receded into the background at parties, show up partly cut
off on the edges of group photographs, are omitted from the indexes of con-
temporaneous accounts of the scene. In old age, however, by dint of having
outlived their peers, they become emblematic of that very time when they
were so overlooked. Often they grow into their roles. Mild eccentricities meta-
morphose into style. They cannily employ their knowledge of elapsed time
to best their once-triumphant dead rivals. They become epic. Even if they do
not actually accomplish anything they become convenient recipients for
tributes to an era whose most prominent specimens are now unavailable for
conferences and photo opportunities. Sometimes, indeed, accomplishment is
beside the point, since their very existence is sufficient as proof that there
once occurred a time that was populated by figures who seem outsized when
compared with the puny careerists of the present. Every generation finds
its own version of this phenomenon, and—for all that nostalgia is a drug—
every generation is right. Every generation is more impressive than the ones
that succeed it because every generation discovers or initiates something
important that is then copied, and further degenerates with every turn of the
calendar. (The corollary, of course, is that every generation is superior to its
predecessors, since it discovers or initiates something that earlier genera-
tions did not even suspect.) But then it seems impossible to imagine the water
tower in its golden youth. It might have been born old; that is its secret.

Seen from the aspect of its beginnings, though, the water tower is a
classic also-ran. For the first century of its existence it is seldom if ever men-
tioned by authors commenting on the urban scene, and it barely shows up in
pictures. You can page through the hundreds of photographs of commercial
and industrial buildings in Moses King's *Handbook of New York City* (1896),
for example, and see maybe half a dozen examples at most, few of them more
than slices. The same applies nearly three-quarters of a century later to
the great battlecry of the urban preservation movement, Nathan Silver's *Lost
New York* (1967)—one or two fragmentary cameos. It might be argued that
the absence of water towers in these cases is merely a matter of the photog-

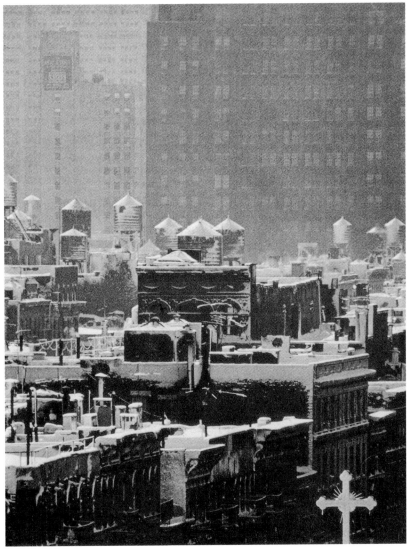

André Kertesz, *New York City*, (detail), 1954　　　　New York Public Library Picture Collection

rapher's street-level perspective, but since the cisterns are sometimes
perched very near the cornice the omission can appear deliberate, not unlike
the way in which photographs of bathrooms until recently always avoided
showing the toilets. When they were not simply beneath consideration they
were considered utilitarian eyesores. Even so, the water tower only rates the
occasional walk-on part in the works of modernists preoccupied with func-
tional details—the shape would seem natural for Charles Sheeler, for instance,
but it can be spotted only in the 1926 lithograph *Delmonico Building* and in
a 1950 street photo. Even Edward Hopper only painted it a handful of times
(*Manhattan Bridge Loop*, 1928; *Morning Sun*, 1952). Serious documentation

for purposes other than those of the water-tower industry itself only begins with the photographs taken by Bernd and Hilla Becher in 1978 and 1979. Nine examples from lower Manhattan rooftops appear in their collection *Water Towers* of 1988—nine examples that, along with two wooden cousins from rural America, contrast emphatically with the steel or concrete, armored or Martian or faux-medieval models from the rest of the Western world.

It is the Bechers's mission to document with scientific rigor the architectural remnants of the age of industry. Their work illuminates the sculptural beauty of objects that were for a long time scorned or effectively rendered invisible, and by the same token pays tribute to the great anonymous assemblage of their designers, builders, and daily users. They do not aestheticize labor but demonstrate aesthetic qualities already inherent in their subjects. In many cases the objects they photograph were supplied with formal qualities by architects whose intentions presumably spanned the range from the quixotic to the condescendingly philanthropic. The water towers of New York City are a significant exception. They were never intended to be any more than strictly utilitarian. Seen in the light of the present day, their aesthetic merit resides in their abject and uncompromising simplicity. Their simplicity stands in stern contrast to the formal complexity of the buildings they adorn, a simplicity that appeared embarrassing if expeditious at the time of construction. This simplicity has now finally clocked in at an historical era that treasures it as an ideal. At a time when formal consciousness has become so overwhelming as to be crippling, the unconscious gesture remains the only totem of unimpeachable authenticity.

The water tower is like one of those deep-sea fish discovered in the 1950s—a living fossil, prehistoric and yet still viable. What once appeared shabby is precisely in tune with the prevailing mood. Down the street, some people have just paid to have the timbers of a collapsed barn trucked down from Maine to serve as cladding for their interior walls. The farmers are only too happy to be rid of them, and the money is gravy; now they can finally erect a structure made of concrete blocks and corrugated steel. The customers appreciate the barn wood because it reminds them of arcadia; because the supply of it is dwindling; because it is weathered while newer construction materials fall to pieces before they acquire a patina; because people like the farmers now scorn it; because they work all day amid glass and steel and concrete. Perhaps their livelihood is derived from an investment in a future that looks to be composed entirely not even of glass and steel and concrete but of plastic—all the more reason why they take comfort in their barn

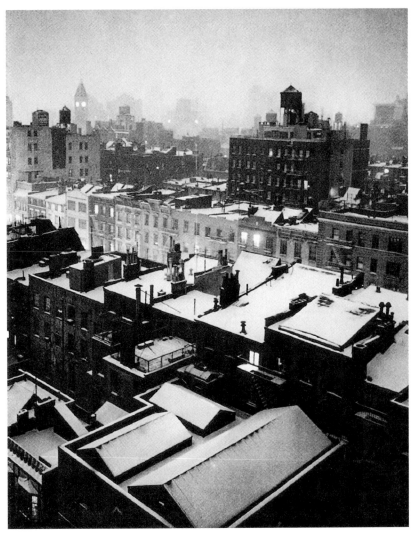

André Kertész, *New York City,* 1954

wood. It is a pleasure not altogether unlike Marie-Antoinette's as she played
shepherdess on the grounds of Le Petit Trianon. Rusticity is their dream of
utopia, their symbol of resistance to the world they themselves have made.
The water tower, hovering above the rooftops, is an accomplice to this fan-
tasy. Its surface is like that of the barn timbers, its shape as elemental as
a butter churn's. It fits right in with mourning benches and grain cabinets and
hardware-store shelving with worn-away, milk-based green paint. But the
water tower will outlive this moment too. Its mystery is utilitarian. It can
laugh at aesthetics just as it can scorn progress. Through guile and happen-
stance it has managed to achieve what few man-made objects ever have:
an honorary membership in nature.

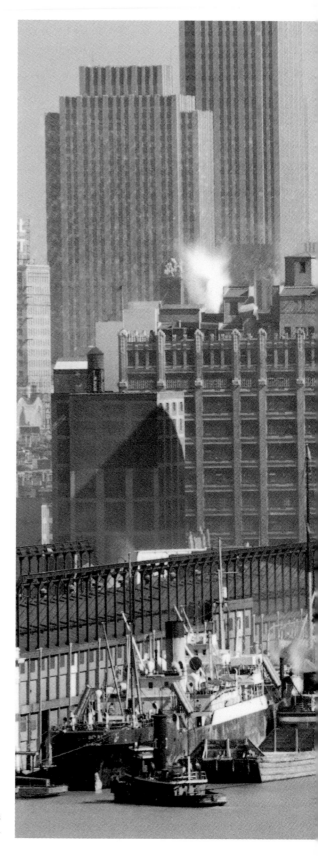

Andreas Feininger, *South Sea Port, New York City,* 1942

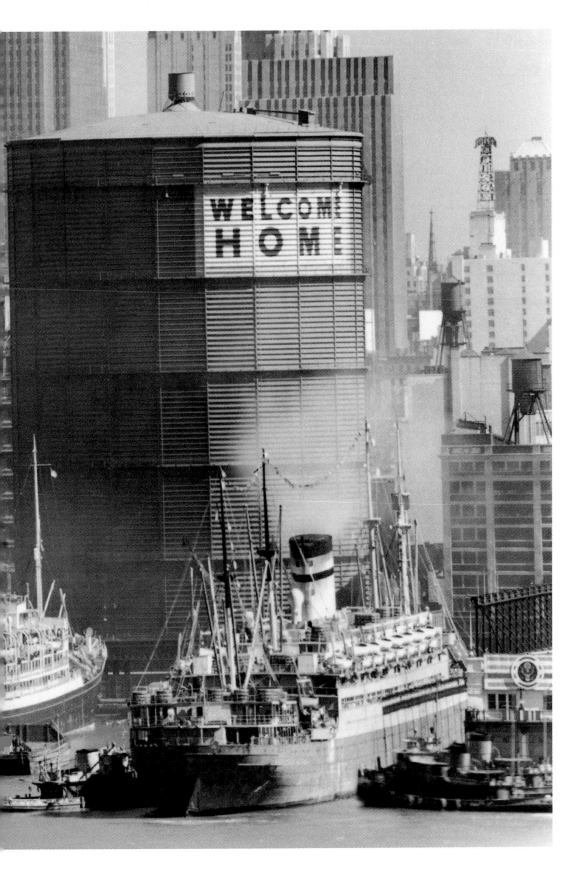

Birthday card from Rachel Whiteread to Louise Neri, May 11, 1997

THE IMMIGRANT

The scene is set. A clear water tower, its walls gone, sits blankly against a white sky. Words from the diary of a German artist are heard. His name is Gerhard Richter. Like the water tower, he addresses the city of New York.

> The more the city fascinates me, the more I suppress the over-
> whelming rage and hostility that I feel towards this city, in all its
> magnificence, modernity, beauty, and above all its incomparable,
> unmatchable vitality, which are denied to me, and which I can
> only admire, full of envy and raging, impotent, hateful jealousy
> (as a Cologne, Düsseldorf, Dresden man); this city of the elect
> and the privileged, of wielders of power and decision-makers,
> which implacably raises up and destroys, producing superstars
> and derelicts; which is so merciless and at the same time so
> beautiful, charming, dreamlike, romantic, paradisal. The city that
> exerts such a deadly fascination; the city that has killed many
> others besides Palermo. This city, this monster, with its tall, old
> buildings that seem so familiar and cosy and convey such a sense
> of security. I envy the New Yorkers, and I think with discontent
> of Germany, the stifling fug of its society, its affluent philistinism,
> its all-smothering, oppressive ugliness. I shall rebook tomorrow
> and fly home early.[1]

In the distance a plane in retreat.

Manhattan has many skylines, all of them deadly and fascinating, a grey sea of waves. Big cities often drown their young as well as their artists, their own as well as their outsiders, but New York's version of this treachery usually strikes after a dream dissolved in gold. The dream contains recurring episodes, applause, excitement, the rush of windfalls, profits. The mythical skyline arches over it all and has succeeded in becoming the dream's physical equivalent, which is why New York has dominated the idea of the city in the twentieth century and been the measuring stick for all the others. Nowhere else has an urban sea seemed to reach from the depths of hope to air.

At the edge of the scene any number of words could be heard. Like Richter's they are isolated lines, spoken from the past, offstage. Ten years

before Richter, Josef Beuys had made an entrance, all wrapped in felt, in New York to live with a coyote in an art gallery, proclaiming that he liked America and that America liked him. America is not usually measured in coyotes. Nor is New York, where locals have been more inclined to calculate in terms of rats. A few years after Beuys, the Dutch architect Rem Koolhaas would come and count the rabbits, their population by then pretty much erased in the evolutionary step toward what he was calling the modern city's Culture of Congestion.[2] He himself would neither romance the city nor leave it abruptly; he just called himself Manhattan's ghost-writer, a young architect sketching a collective delirium terminating on a grid. Only later would he acknowledge the strength of the tide. "This architecture," he said, for he now wrote more summarily, "relates to the forces of the *Großstadt* like a surfer to the waves."[3] Foreigners have often seen New York's surfaces better. They have the advantage of seeing them fresh.

Recently the Public Art Fund gave Rachel Whiteread, who is English, the opportunity to make the clear tower. She made it cloud but kept it light. She wanted to find a form that would take one away from the city crowd and produce a brief difference, an interruption, "a peaceful moment" she kept saying, that would draw no particular attention to itself.[4] She told those who kept asking that she wanted "to make something not there."[5] She stayed away from both the crests and the streets. Her tower redraws the line between the city and the sky from a point not even ten stories up. It is as if the entire skyline has been lowered, as if something had pulled on the fable's hem, something going under the urban surface here. But Whiteread knew her tower would be subjected not only to the implosion of the *Großstadt* but to light. "On a cloudy, gray day," she explained, "it might just completely disappear. And on a really bright blue-sky day, it will ignite."[6] She would retreat from the skyline to return to it.

Right away Rachel Whiteread saw that she would retreat and return through the figure of a water tower and that she would be casting an existing wooden one of the nineteenth-century type into clear resin. For those familiar with her work, this seemed perfectly logical. Rachel Whiteread is known for her casts. The casting she favors is descended from the ancient craft process of retreat and return in which a mold is made of an object, the mold is removed and then separately refilled with another material. Molds were made to be broken at the end of the process; typically the finished product emerged made of something else. Through the ancient process, objects found their

negatives and then through a transformation lost themselves and them; one surface detached from another only to be itself subjected to a new surface's detachment from it. Objects kept coming, then their solid shadows, from which emerged new objects. Objects were not exactly returning, it would be better to say they were recurring. The tower would be no exception.

The tower would be cast and brought back in resin, lighter, a clear ghost of itself, looking like nothing, looking like solid water. It would seem intangible and weigh four and a half tons. Close up its surface still shows the imprint of the original wood wall but from a distance it looks as though any trace of the wall has vanished entirely, leaving only the contents to stand there, rather improbably, straight. But in fact only the inside of the tower has been cast, which means that the clear tower is actually no tower at all, only an unbroken mold which has pulled an inside, a void, solidly out. It sits on its dunnage as a vision and a riddle, a surface. That's all. No other tower will ever be cast from it. Water must tower. A negative must be read positive. Whiteread made all this read for the city.

The surfaces of her earlier work had been fairly clearly pulled from the surface of death. As if to explain she would tell her first interviewers about having had an odd job cleaning up in Highgate Cemetery; she might go on to tell of a TV documentary showing the metal coffins at Spitalfields being relieved of a sludge.[7] Her early cast of a Victorian room would bear the title *Ghost*; her early cast of the space under a bed would be called *Shallow Breath*. She would speak at some length of the importance for her of J. G. Ballard's novel *Crash:* "It was the exploration of the sexual nature of our relationship with machines that interested me. ... The main character is obsessed with the eroticism of mutilation and wounds inflicted by car accidents. Seeing the imprint of the dashboard on someone's face. It's a bizarre kind of casting; the imprint where the animate and the inanimate meet." And then she would continue, "although I don't think my work is necessarily about death. It has to do with the way our culture treats death; other cultures celebrate it and we try to brush it under the carpet."[8]

She herself brushed death somewhere else in order to meet it and cast it. The precise location and composition of death remained mysterious. Somehow she got it outside. She showed her results, rough plaster surfaces bearing the touch of former surfaces, sometimes lower-class Victorian walls, sometimes plain ordinary things. She was making casts from a variety of different materials, using a range of colors and textures that as much as suggested human body fluids and postures, clitoral folds and nipples and

she would say so. She still was casting used things, household objects and the furniture of rest, bathtubs and mattresses and chairs. She would prospect for these objects in roadside rubbish and flea markets, not minding that the old things heaved the touch and smell of humanity at her as she took them away. She fully accepted the possibility that she might find their piss on her face.[9] But ultimately hers would be a dry theatre of casts without characters and she herself would offer fewer and fewer words to their viewers. Things alone would enact the shift of a life out of time, out of body, the shift to another color and dust. In their recurrence they appeared to contain the force of a fate. But they never would speak, not even in oracles, not even through questions.

One wishes for words though, or at least better vantage. For one must go higher than skyscrapers to speak of this kind of encounter, outside, with death and even then simple overviews are impossible. Nietzsche gave his overman, Zarathustra, the power to see these things. But what could Zarathustra say after the sight? Zarathustra began by speaking to the sun and then descending, in Nietzsche's words, going under. He would pull his own abyss out into light. But Zarathustra himself would fall and nearly die from the nausea brought on by this unthinkable inversion of consciousness. "To every soul there belongs another world," he said afterward to his animals; "for every soul every other soul is an afterworld. Precisely between what is most similar, illusion lies most beautifully; for the smallest cleft is the hardest to bridge." And the animals would reply at length, formulating this recurrence for him as the existence of being in every Now, and the sphere There rolling around every Here.[10] They begin to describe something of the effect of Whiteread's procedure, her molds' small clefts and their sensation of some latent There. Her traffic with the after-life is not modern.

In ancient Egypt the exchange with death was understood to take many lifetimes; mummification built man a stage known only to the tomb. In ancient Greece, it was understood that this kind of knowledge, if brought to light, could weaken and defeat a city. Remember the wooden horse. But this is the late twentieth century. Wooden horses no longer hold armies and Zarathustra's animals have scattered. Ours is a time of little explanation. The city of London can be surprised from the East by a sculpture. This occurred in 1993 when Whiteread took a Victorian terrace house in East London, in Bow, that had already been slated for demolition and, as a commission for Artangel, cast its interior into a concrete block.[11]

Her *House,* as it was called, stood on a green, alone, oddly solid. Its surfaces had once contained the air of an actual home but the air, warm or damp, and the talk inside was all gone now, sucked out before it could be fanned into the echo and scuttle around it. *House* took the Here-and-There paradox to an architectural scale. Whiteread would speak of having wanted to mummify its space.[12] This time around everything she said in public was being quoted extensively. She found herself being turned into a suspicious person. Suddenly everywhere there were many people beside her and they were speaking at once.

House attracted the attention of the city in a way that few works of art in our time have managed. Torrents of admiration and abuse of all kinds were unleashed. Some took the form of words scrawled on the house itself: "HOMES FOR ALL BLACK + WHITE." "WOT FOR?" "WHY NOT?" Some became pictures. A happy face turned up; so did a skull and cross-bones. Sidney Gale, the former owner, complained loudly, not realizing how his small attempts at politeness would be made to sound in the press. What did he think when his words became broadsides for attribution, announcing "they've taken the wee wee out of me?"[13]

The critic for *The Independent* praised *House* as extraordinary.[14] The local councilor, Eric Flounders, called it an "excrescence." Flounders received much press coverage for his repeated attacks on *House.* At one point he wondered why someone, for he addressed a particular interlocutor, "from the leafy elegance of South Edwardes Square, where a lump of concrete of this type would never be tolerated, feels able to inflict this monstrosity on a local community which has clearly said it does not want it. Public sculpture," he continued, clearly warming to the larger issues raised by his subject, "is answerable to those whose environment it inhabits, and on that basis *House* has no place in Bow. Nor, for that matter, do the disruptive crowds who come to see it. The argument that it 'makes people talk' is equally absurd. A ten-foot pink plastic penis in the middle of South Edwardes Square would make people talk, but I doubt if you'd favour it."[15] But there were those in Bow who called it lovely, like the bus driver who lived across the street.[16] The British tabloid press kept its own sarcastic, running score. What was it about *House* that made people scramble for alternatives like this? *House* itself simply stood there implacably against the charge, faced with a city, an unwanted chorus, wild words, and a circus. The conditions of theatre do not quite suffice to describe all the play in this situation. The scene in London had unraveled. Congealed air met the wind.

House was demolished in early 1994, as planned, after being shown
for three months. Its demolition finally cleared the block to which it had once
belonged and let it become a fully green space, the kind of new urban condi-
tion advocated by the councilor. But if this can be considered a war, *House* was
Whiteread's victory. For it she won Britain's Turner prize. Meanwhile she had
started a fellowship year in Berlin, had already participated in Documenta IX
and was now using not only London, as she liked to say, for a sketchbook but
also Germany.[17] Her work moved easily through the corridors of the interna-
tional art market. In 1994 the Public Art Fund in New York commissioned
Water Tower. Not long after that Whiteread would win the competition for a
Holocaust monument in Vienna and in 1997 she would be chosen to represent
Great Britain at the Venice Biennale. She had begun working more consistent-
ly with, and on a large, often architectural scale. And her work had come to
pull its insides out into outsides farther and farther from home and the grave.
It could now expect to face an ever-widening scene, a spreading outside,
a locale looking more like a world. Was it only an art world? Can such an out-
side even be considered a city?

What is a city? By now the answer to this question is not obvious even
to professionals. The very icon of metropolis, New York, is fluctuating un-
naturally. And the dream of gold? New Yorkers always knew they lived in a
city constantly being re-articulated, especially if one looked close, but these
days the pace of change, much remarked, is fast. The city is being penetrated
by massive new influxes of foreigners, who bring to town not only fresh
sources of labor but also fresh capital for investment and development.
The immigration rate is now as high as that at the beginning of this century.
Immigrants comprise more than a third of New York's 7.5 million inhabitants.[18]
Currently the city's immigrant population is counted at 2.7 million (or 36%
of the city), with 60% of its population either themselves immigrants or
children of immigrants. Most are black, Latino, and Asian.[19] They speak many
languages. They bring economic links with them that cross urban and national
borders. For this flow of labor and capital is fueling the late twentieth cen-
tury's transnational economy. A new dynamic of retreat and return, dream
and danger, hope and air, is resetting the city's image and redrawing the
city's limits. The conditions of theatre do not describe this situation either.

Above planes arrive. The new immigrants, whatever their social class,
move differently than their forerunners did. They usually keep real contact
with their homeland, telephoning it often and flying home periodically.

It is not unusual for immigrant communities to operate their own native-language radio and TV channels and to broadcast the day's regular programming from home. The Koreans in Queens, the Russians in Brighton Beach, the Dominicans in Washington Heights, the West Africans in the Bronx, for example, have new ways to grasp the simultaneous presence of There and Here and Now. They have lives of global scope. Their paths can subsume the same cities that once consumed souls. The skyline is being crossed daily. Above planes depart.

These conditions do not appear as random or loose generalities. Typically people express them differently. For half a century, the New York community from the Mexican village of Chinantla has made an annual pilgrimage back. Leticia Lopez goes on break from college with everyone else to admire the sky, "nice and blue," and the quiet. "People [there]," she says, "don't go through the same crazy routine: wake up, go to school, go to work, go home, eat dinner, go to sleep. Down here life has time to breathe."[20] Liliana Maldonado, a computer student, makes a similar trip every summer to her parents' hometown in Ecuador. "What it feels like to me," she says, "is a relief."[21] But these are pauses in a rhythm that returns them to New York. Fernando Mateo, a successful businessman known nationally for his campaign to trade toys for guns, a child of Dominicans and a man who, like many new immigrants, holds onto dual citizenship, expresses his and their situation very simply: "I believe people like us have the best of two worlds. We have two countries, two homes. It doesn't make any sense for us to be either this or that. We're both. It's not a conflict. It's just a human fact."[22] It's just the route they take with their families through life to death. In 1996 more than half the Dominicans and Mexicans, a third of the Ecuadoreans, a fifth of the Jamaicans, and sixteen percent of the Greeks who died in New York City were sent home to be buried.[23] They will not have been immune from New York's treachery; the living know they could well find themselves in the position of Amadou Diallo, a Guinean street vendor who had already divided his childhood between Liberia, Thailand, and Singapore while his parents set up their business in gemstones. As a teenager he too would spend summers in his parents' village of Hollande Bouru. And then he would come to New York and die young when forty-one shots were fired at him by police as he stood unarmed in his doorway.[24]

When Rachel Whiteread looked for a peaceful moment in this New York City newly awash in new people, did she know that it was now regularly being found in Africa, in Mexico, in Ecuador? And that such a peace was not taken as a vacation? She gave peace an urban shape in her inverted tower

of water. Was it rural? She had once described a rare country moment, "when there are no birds singing and there's no wind, you just get this silence that is absolutely concrete, it completely smothers you."[25] It gives the country an urban condition. But New York is not itself capable of this kind of silence. Moreover New York no longer seems solid.

The new immigrants have been joined by an equally dramatic increase in new tourists, many of whom are American citizens. It is said that last year some 33 million tourists came to New York, of which only a fifth were foreign.[26] But New York's expanding tourist industry is geared toward the foreigners, for they have been shown to be the economic force, spending some $1.3 billion last year just on shopping whereas all the American tourists put together doled out not even half that.[27] Compared to the super-profits of the city's financial and real estate markets, this seems relatively small, potatoes in comparison, but the combination of all these different capital expenditures has led to a much higher level of sales pitch and prosperity on the city's streets, one aimed at everybody. The streets of Manhattan teem with the activity of mixed economy, increased services, hype. There is more neon, larger signage, a faster flicker and a growing electronic shine. This is a city proposing a glowing transnational scale for the measurement of life. It is no longer defined by monuments or waves. Infatuated with both Wall Street and Times Square, it has yet to find a single image. It may not have an image.

Against this scene, which is shuffling people and light and is at heart sceneless, Rachel Whiteread wanted her *Water Tower* to sit, not there. She had hoped to find a site for the tower in an anonymous neighborhood. The best site to emerge was ironically in SoHo, the old seventies art neighborhood in lower Manhattan that had become synonymous with the eighties art boom and is now being further revised into a zone of luxurious residence and retail. SoHo too has its share of large signage. The rents for its retail spaces have increased by half during last year alone. Another magnetic combination, an aesthetic patina, a haven for new tourists.[28] On the day of *Water Tower's* installation, Rachel Whiteread joined them. Standing on the street, she remarked to no one in particular, "I had nothing to do with it. I'm just a tourist."[29] Is this a fact?

What is an artist? Neither tourist nor traveler exactly, Whiteread works in New York temporarily, a foreign artist making foreign art, in this case a tower organized by the American-based and privately operated Public Art Fund and sponsored by Beck's, the German beer. One would not want to call her

an immigrant. Artists usually are not. Immigrant remains a word laden with inferior, unprofessional class connotations, despite all the late twentieth-century evidence to the contrary, despite the mutation of the term immigrant into a word of increasing ambiguity. Let us say to begin with that Rachel Whiteread's sphere of operation and the scope of her work makes it necessary to call her a global artist, a global artist being nothing less than a form of new immigrant, a person perpetually half-assimilated and airborne, a living soul always there and not there. Her *Water Tower* takes on many of the qualities of the immigrant as it rises above the domain of all the people, all the characters. It rises above the skyline to be seen above it against the sky. However it looks more like the city. It will be a sceneless structure. In that way it speaks not only for the new urban fabric but also to the new condition of the global work of art.

The imploding spine of the art genealogies cannot very well explain or support *Water Tower* any more than a borrowed scenario will. So much has had to go under to get to this point. The individual work of art has had to step beyond itself and aspire to the size and capitalization of architecture in order to register its individuality and find notice internationally, even if it does not want to abandon its former activity entirely and become architecture outright. It is frequently said that this greater size and cost make it more difficult for collectors and even museums to hold the large work of art. But equally there are blessings. For a large work of art like *Water Tower* is in effect asking to be held only by the world. There it can enter the expanding scene of global lives; perhaps there it will find and touch them. Perhaps in its inversion of urban conditions solids will exist as mobile voids. Neither self-contained nor a self-figure *Water Tower* retreats and recurs; it can be there and not there; it can renew ancient casting techniques; it turns on an antiquated form. It can show the present and the past something of their place. It can trade in paradox. It seems to hold paradox. Therefore it cannot simply be a tower. Let it also be a well.

As Zarathustra traveled further along his path, he made a practice of speaking in aphorisms that tested perception, for he disdained the practice of knowledge as nut-cracking.[30] He tried instead to show what another way of thinking might entail. "Ice-cold," he declared, "are the inmost wells of the spirit: refreshing for hot hands and men of action." His disciples listened. He continued, "You stand there honorable and still and with straight backs, you famous wise men: no strong wind and will drives you. Have you never seen a sail go over the sea, rounded and taut and trembling with the violence of

the wind? Like the sail, trembling with the violence of the spirit, my wisdom goes over the sea—my wild wisdom."[31] Ultimately he would prefer to use song to express this path of his thought, though his songs have no score and sound like puzzles. Even in the late twentieth-century city, there is no singing them again. Zarathustra too can only speak now from some indeterminate point offstage. If night has come and all fountains speak more loudly, how now is Zarathustra's soul too like a fountain?

Can a tower too be water? Can water be sky? No city on earth, no life on earth, has the scale of the sky. Whiteread has given her tower an unusual ability to contact it, as if through light alone the tower could come to detach and attach to its height. The tower lets the light of the sky fall through it like fire; at night it hides. In its clarity it accepts the sky's every mood, every color, every darkness, every dawn. And yet the tower cannot transcend itself and become death or sky, it must keep the form of a tower, of its nothing, of its water. Some call it a ghost. Sometimes it plays like a child as a cloud. Yet through it, an idea of another life is being washed upward; an idea is being defined by the elements. We have come very high. Clouds are notoriously silent. Normally water falls.

[1] Gerhard Richter, *The Daily Practice of Painting: Writings and Interviews 1962-1993*, ed. by Hans-Ulrich Obrist, trans. by David Britt (Cambridge: MIT Press, 1995), diary entry dated September 6, 1984, pp. 108-109.

[2] Rem Koolhaas, *Delirious New York: A Retroactive Manifesto for Manhattan* (2nd ed.; New York: Monacelli, 1994), see especially the introduction. First edition 1978.

[3] Rem Koolhaas, "Delirious New York Redux," *Zone*, nos. 1/2 (undated), p. 448.

[4] See the interviews with Jonathan Jones, "East End or West Side—Home Is Where the Art Is," *Independent* (11 Feb. 1998), with Carol Kino, "Up on the Roof," *Time Out* (June 4, 1998), pp. 67-68 and with Carol Vogel, "SoHo Site Specific: On the Roof," *New York Times* (June 11, 1998), p. E4.

[5] "Eyes on the Skies," *Artforum* (January 1998), p. 34.

[6] Both statements are quoted by Darcy Cosper, "Rachel Whiteread's Water Tower: Casting New York," *Metropolis* (June 1998), p. 99.

[7] See especially Iwona Blazwick's interview with Rachel Whiteread, done in Berlin in October 1992, in *Rachel Whiteread* (Eindhoven: Stedelijk Van Abbe Museum, 1992-93), as well as the interview with Lynn Barber, "In a Private World of Interiors," *The Observer Review* (September 1, 1996), pp. 7-8 and the interview by Andrea Rose in the 1997 Venice Biennale catalogue, pp. 29-35.

[8] Whiteread quoted by Doris Van Drathen in her article, "Rachel Whiteread: Found Form, Lost Object," *Parkett*, no. 38 (winter 1993), p. 31. See also the Blazwick interview.

[9] Blazwick, p. 13.

[10] Friedrich Nietzsche, *Thus Spoke Zarathustra: A Book for All and None,* trans. Walter Kaufmann (New York: Modern Library, 1995), pp. 217-218. The book was published in stages in 1883, 1884, and 1892.

[11] *House* has been given excellent critical assessment in *Rachel Whiteread House,* ed. James Lingwood (London: Phaidon and Artangel, 1995).

[12] In her interview with Francesco Bonami, "The Nothingness Supplied With Space," *Art from the UK* (Munich: Sammlung Goetz, 1998), p. 158.

[13] *Rachel Whiteread House,* p. 133.

[14] *Ibid.,* p. 134.

[15] Councilor Flanders is quoted by Simon Watney in his essay for *Rachel Whiteread House,* "On *House,* Iconoclasm & Iconophobia," pp. 105, 108.

[16] *Rachel Whiteread House,* p. 138.

[17] Christoph Grunenberg, "Mute Tumults of Memory," essay in *Rachel Whiteread* (Basel: Kunsthalle Basel, 1994), p. 20.

[18] The number of immigrants coming to the United States in this decade is expected to reach 10 million, surpassing the record of 8.8 million from 1901 to 1910. These figures come from the Immigration and Naturalization Service, as quoted in "Record Immigrant Flow Fuels U.S. Home Market," *New York Times* (July 2, 1998), p. F9.

[19] Deborah Sontag and Celia W. Dugger, "The New Immigrant Tide: A Shuttle Between Worlds," *New York Times* (July 19, 1998), pp. 1, 28-30. For an extensive discussion of the phenomenon globally see Saskia Sassen, *Globalization and its Discontents* (New York: New Press, 1998).

[20] Deborah Sontag, "A Mexican Town That Transcends All Borders," *New York Times* (July 21, 1998), p. B7.

[21] Sontag and Dugger, *op. cit.,* p. 30.

[22] *Ibid.,* p. 1.

[23] *Ibid.,* p. 28.

[24] Amy Waldman, "Killing Heightens the Unease Felt by Africans in New York," *New York Times* (February 14, 1999), pp. 1, 39; Susan Sachs, "Top Officials In Guinea Meet Plane Carrying Peddler's Body," *New York Times* (February 16, 1999), pp. B1, B5; Susan Sachs, "Slain Man's Mother Is Center of Attention in Guinea," *New York Times* (February 17, 1999), pp. B1, B5; Susan Sachs, "Wanderings Over, A Son Is Laid to Rest," *New York Times* (February 18, 1999), p. B5.

[25] Blazwick p. 11.

[26] "Giuliani Takes Credit for Growth in Tourism," *New York Times* (August 25, 1998).

[27] Leslie Eaton, "Chic Has a New Address," *New York Times* (November 27, 1998), pp. B1-4.

[28] See Roberta Smith, "The Ghosts of SoHo," *New York Times* (August 27, 1998), pp. B1-2 and Terry Pristin, "In SoHo, Consumerism is an Art," *New York Times* (September 26, 1998), pp. B1-2.

[29] C. Carr, "Going Up in Public," *Village Voice* (June 23, 1998).

[30] Nietzsche, *op. cit.,* p. 125.

[31] *Ibid.,* p. 105.

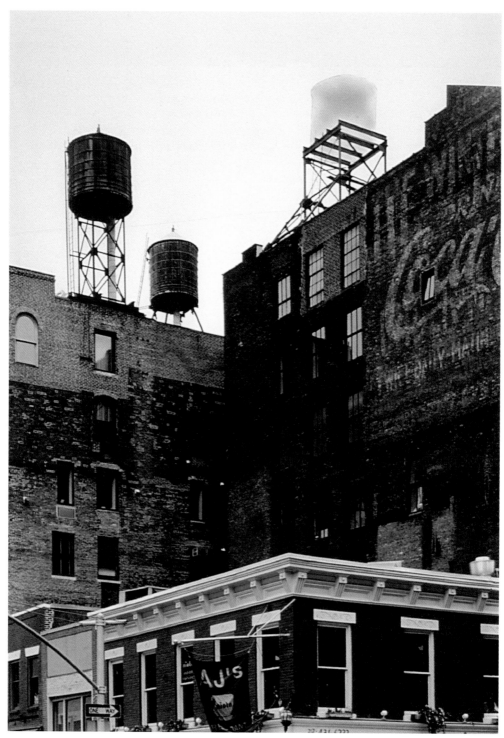

Rachel Whiteread, Study for *Water Tower,* varnish on photograph

SOURCES FOR *WATER TOWER*

COMPILED BY RACHEL WHITEREAD

Koetlitz Glacier, frozen pond

Laboratory-synthesized ice crystals

Convective clouds

Cloud formation

Cumulo-Nimbus formation

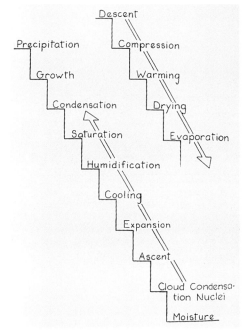

The Precipitation Staircase

Photomicrographs of snow crystals

Plastic replica of a stellar snow crystal

Ice storm

Ice storm

Hailstone

Hailstone

Types of Frozen Precipitation

The World of Clouds

Plowed-up airfield, 1942, Ghindel, Libya
The Imperial War Museum, London

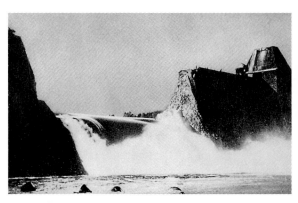

Breach of Möhne Dam

Engraving of the ghost that appeared to a Norfolk miller in 1602

William Marriott's drawings and photographs illustrating the deception by which "spirits" were made to materialize from the corner of rooms

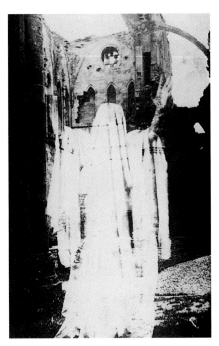

The Spectre Monk, a photograph by the ghost-hunter and *Picture Post* photographer Robert Thurston Hopkins

Wax "gloves" produced by a spirit dipping its hands in a bowl of wax. Produced by Franek Kluski, a Polish medium (c. 1920)

Molds made by spirits impressing their faces into soft wax.
Produced by Franek Kluski, a Polish medium (c. 1920)

"Ghost" at Raynham Hall in Norfolk

Bacteria (streptococci) being devoured by white blood cells

A single cell of protoplasm

Depression

Rainmaking

Sunshine Recorder

Galeolaria Lutea

Acanthometra Bulbosa

Aulocantha Scolymantha

Apolemia Contorta

Llyn Brianne Dam, Llandovery
Postcard

Llyn Brianne Dam, Llandovery
Postcard

Ectoplasm (Stanislawa P.,
a Polish medium)

Ectoplasm (The medium Jack Webber,
London, c. 1930)

Study of ectoplasm, University of California, Los Angeles, 1972

Study of ectoplasm, University of California, Los Angeles, 1972

Glacial berg off the coast of Antarctica

The Tower of Silence, Iran

Roman aqueduct at Segovia, Spain

The third pyramid at Giza, Egypt

The Horseshoe Falls, Niagara, NY

Niagara Falls by night

Niagara Falls in winter

Electron micrograph picture of snowflakes

General arrangement of domestic water system

Dyke of igneous rock (basalt) traversing sedimentary strata

Hand-operated dam

Frozen dyke

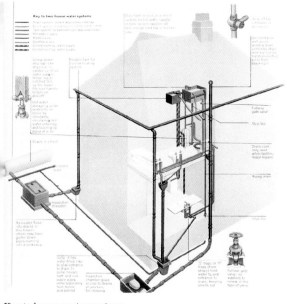

Key to house-water systems

Nineteenth-century representation of Manhattan island upon its discovery by Henry Hudson in 1609

New York City street

Hudson River waterfront near Greenwich Village

Practical perspective drawing

Practical perspective drawing

Practical perspective drawing

Practical perspective drawing

Making models

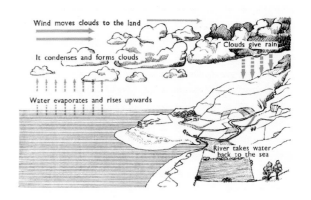

Rain cycle

Cloud formation two hours before tornado strikes

Funnel begins to form

Tornado draws water from a pond in its path

Tornado strikes and wrecks a ranch

Damage done in St. Louis, Missouri, Sept. 30, 1927, by tornado
lasting five minutes

Straws driven into the bark of a tree by wind of hurricane force
in Minnesota

The aqueduct of Carthage, Tunisia

The Pont du Gard, near Nîmes, France

Cold Water Cistern

Eight Arch Bridge, Stackpole, Pembrokeshire
Postcard

Flooded railway station
British Railways official photograph

Lightning

A close view of Niagara Falls

Victoria Falls, Zimbabwe

The Queen Mary

Graduations under water appear to be closer together

The saucer appears to be shallower when it contains water

When in water, the ruler appears to be bent

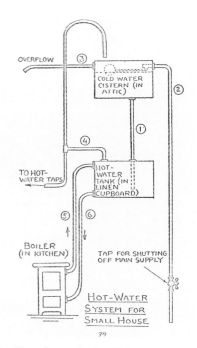

Hot-Water System for Small House

Man-made clouds from the exhaust gases
of aeroplane engines

"Festoon clouds are a more drooping and
sorrowful kind than the ones we call mackerel sky."

"Viewed from their own level, clouds are seen to be only large
or small wisps of mist."

"On a mountain above the clouds there is clear sunshine, while
in the valley below the cloud blanket it is sunless and gloomy."

Aswan Dam, Egypt
Postcard

The screw of Archimedes system of irrigation, Egypt
Postcard

The Small Pravcice Cone formed from natural
concrete, Prague
Postcard

Llandovery Dolauhirion Bridge
Postcard

The Cavern End, Kent's Cavern, Torquay
Postcard

The Great Globe, Durlston Country Park, Swannage, Dorset
Postcard, The Delpool Picture Library

Aswan Dam, Egypt
Postcard

Vallée de la Cure—Le Vieux Pont
Postcard

"A fish that acts like a frog"

Minute jellyfish

A Sockeye salmon

RACHEL WHITEREAD

WORKING NOTES

Closet (1988), my first sculpture: This set the pattern of the work over the past ten years. I wanted to fill a wardrobe to make a black, concrete space, a place connected to childhood memories. I used a very simple technique which, in essence, has not changed. I had a wardrobe, I laid it on its back, I filled it with

plaster, then removed the wooden mould, and eventually covered it in black felt. This was a very crude method, something I could do in the studio on my own. I don't think my technique has really changed, it's just that the technology I employ has become more complicated.

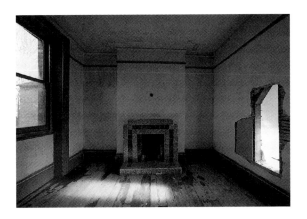

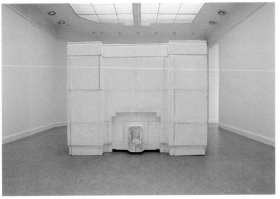

Ghost (1990), my first architectural piece: It was not a public piece as such but it was the first major work that required a large amount of space. When I was making this piece, there were five elements that I thought had to be present: a window, a door, a fire-place, skirting board, and cornicing. I spent three months searching for the room that I could cast and eventually found it in North London, very close to where I grew up. I spent about four months working in this room, casting the piece, and replacing it against the wall as it was cast. I really had no sense

of what it was until I relocated it in the studio. By looking at the light switch, I had suddenly realised what I had done. I had made the viewer become the wall. It was a very strange feeling. Somebody asked me why I blocked up the keyhole in the door-way. I had to, otherwise I'd have ended up having to cast the next room, and then the outside of the house, and then the street ... there had to be a point at which things stopped. So I think this was when I first began to think about proportion and space and composition.

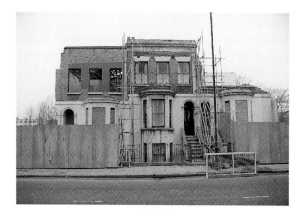

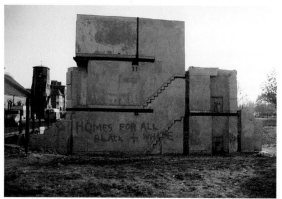

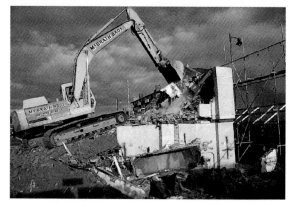

House (1994), my first public commission: When Artangel approached me to make this project, there were all sorts of challenges. The first problem was to find a house that we could cast. This took about two and a half years. This was a semi-derelict house in East London and I was very clear that it had to be in an area that I was absolutely familiar with, and a building that was going to be knocked down. Grove Road was on a green corridor with a view to Canary Wharf, one of Thatcher's troubled economic babies, originally envisaged as an urban utopia.

I worked with engineers, construction people, and a group of artists and students inside the house for about four months. To build a building within a building, we had to make new foundations. We worked meticulously on the interior, sealing cracks and stripping it to its carcass. Then we applied a release agent, sprayed one centimetre of top-coat concrete over it, put the metal armature in place, and heavy-

filled it with the rest of the concrete. It was a very strange place inside, like a cave or grotto. We used that process throughout the whole building; essentially the building became a mould. Then we stripped the whole thing by hand—every brick, every fireplace, every door. When we had finished casting, we got out through a four foot square in the roof. The construction people said that it could just be patched over with wood, but I insisted that it had to be cast so that it would be a completely sealed space.

As we stripped away the building it was amazing to me how much detail the casting had picked up, like *Ghost* but much more substantial, not just because of its size, but because of material and the brutality with which it had been made. By the day of the demolition, it was covered in graffiti and beginning to look pretty sad; birds were living inside it. It took three and a half years to develop, four months to make, and thirty minutes to demolish.

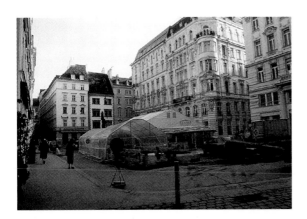

Library (1994–), in progress: The next sculpture that doesn't exist yet is the Holocaust Memorial in Vienna. It was a proposal for a competition. I was reluctant to get involved because, having lived in Berlin for a year, I was aware of the controversy that might occur. But I wanted to see if I could deal with such an intense and emotive subject, and make a proposal for a memorial that was succinct, respectful, and poetic. I proposed a library, cast from thousands and thousands of books, spine inwards, so that there would be no sense of what the books were, with a ceiling rose on the roof for drainage, and two sealed doors. Its proportions are based on a room in a building on the Judenplatz—a square in the centre of Vienna—and

it relates specifically to the proportions of the square. The piece is made out of concrete and sits on a white concrete base upon which is an inscription and the names of all the concentration camps in which Austrian Jews perished.

The site in the Judenplatz is controversial because in 1421 the synagogue that was originally there was burned to the ground and a mass suicide of Jews followed. The city architect had permission to dig the site because a memorial was going to be placed there. In the process he found the bema, the area where the Torah was kept and read from. One of the main reasons that people objected to my work was that it would actually sit on top of this area.

Over the last four years, politics and controversies have hampered the project. But I refused to let anyone interfere with my design. The local community made compromises and now a grand-scale project is in progress which, in addition to the memorial, will include public access to the remains of the original synagogue, a pedestrianised square, and a refurbished Judaic study centre, to be completed by the year 2000.

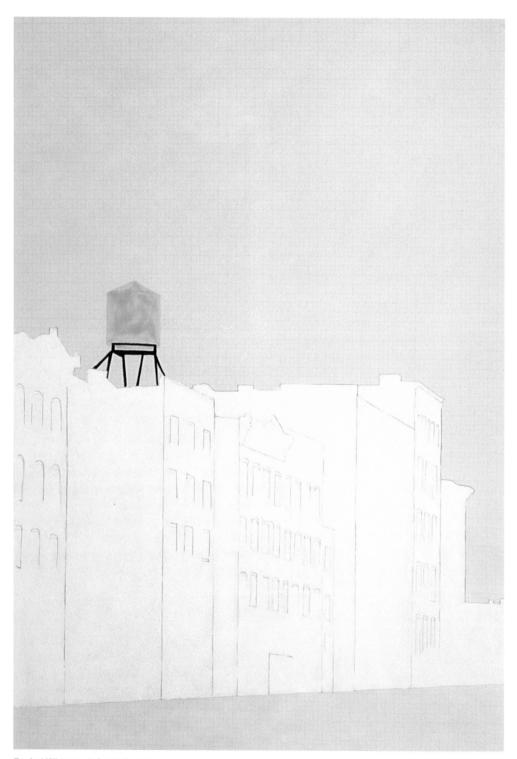

Rachel Whiteread, Study for *Water Tower*, mixed media on paper

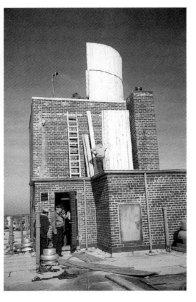 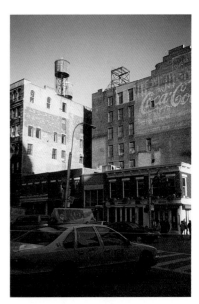

 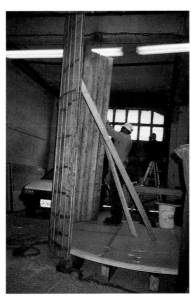

Water Tower (1998): I was looking for a site that was remote but fairly evident from street level, that you could get quite intimate with, that you could see from different vantage points.

The American Pipe and Tank Company would save wooden tanks for me and I would go look at them. We couldn't make a decision about what size the tank would be until we found the site and knew what size

the existing truss was. They took me to see one being put up; they really are just wooden barrels, something that hasn't changed for centuries and centuries in terms of their construction: wooden base, wooden sides, made of redwood or cedar.

Richard Silver, Director of the American Pipe and Tank Company, found the Grand Street site. I like the old Coca-Cola sign, and the different brick work on

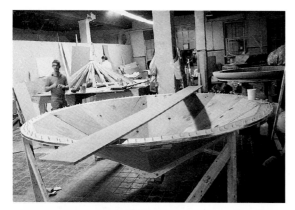

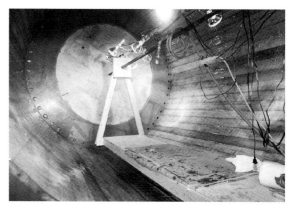

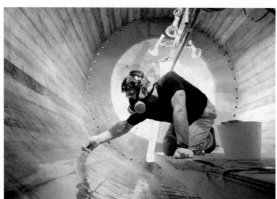

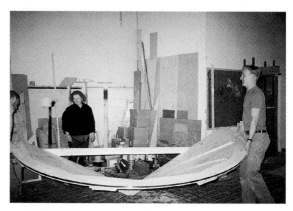

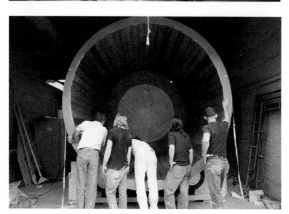

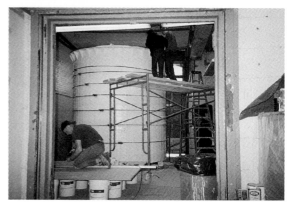

the exposed side of the building. It is a rich site in many ways.

For the material, we worked with a company in Tustin, California called BJB Enterprises. They had just handled the biggest resin casting ever done, installed at the Foxwoods Casino in Connecticut. So we went there to see it, an enormous statue of a Native American, firing arrows into the sky, with a laser show, music, the whole works. So at that point things were coming together.

At this stage, I was also making drawings and trying to work the project through in my mind, but it was very frustrating not being able to actually make it.

We had also found a fabricator, Chuck Hickok. He was quite mysterious. He didn't really have a portfolio because he'd worked for the government, so many of his projects were top-secret. But he had shown me enough for me to be completely convinced by his technical abilities, and we worked very well

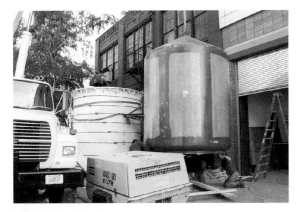
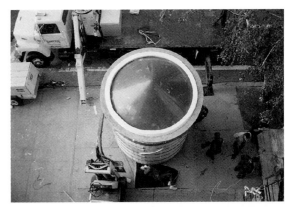

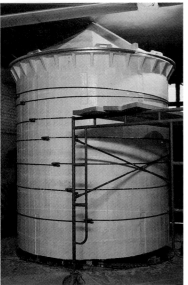
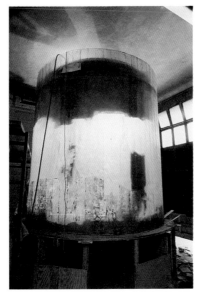
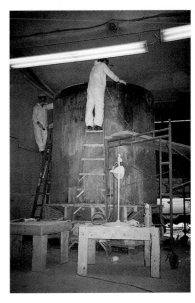

together. So we went to BJB Enterprises and started working on tests. We made a small maquette of the tank, using a stainless steel cone, and it worked well. With Mark Hage, our structural engineer, we assessed the tensile strength, and tried all sorts of methods by which this piece could be made. The release agent didn't really work, and it stuck to the outside—which happened again when we were casting the actual piece.

It became really exciting at this point because we were just beginning to get a real sense of what the piece would look like in different light conditions. We put the maquette up on a forklift truck, and the

guys at the plant were very bemused by me walking around with a camera.

The wooden tank from which we would cast the resin form was sitting in the yard, ready to be reassembled. It had had to be very carefully dried because the slightest moisture in the wood would cause the casting material to fizz, and the whole cast would turn cloudy. I had always wanted to use a tank that had been in use, so that the surface of the wood would be weathered. A lot of this wood was warped, and it was quite an effort to put it all back together again. It was reconstructed as a water tank is constructed, using the metal banding.

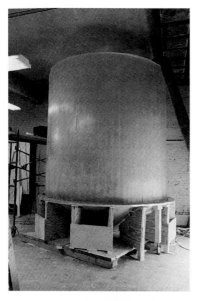
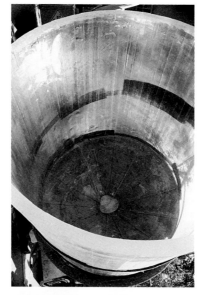
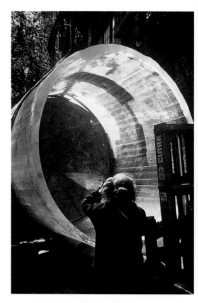

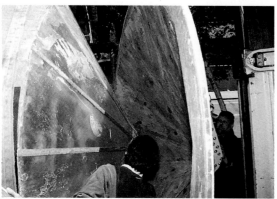
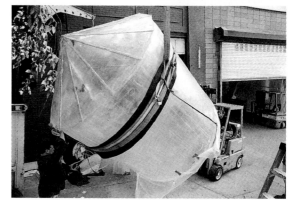

In the meantime, I was working in the studio, trying to figure out the roof for the tank. I had to fudge it a bit to make it work. We were making these plaster models and thinking things through as we went along.

The inside of the tank had to be completely sealed, and the roof and the core constructed from Divinycell H-80 and fiberglass. Ultimately this was the element that really didn't work. The core was put inside the mould and then a layer of UV-resistant medium was painted on the outside of it, so that the cast would turn out bluish-clear instead of yellowish.

The mould was a fantastic object, like a time capsule. A very, very beautiful object. It had been wrapped in polyester and fiberglass to prevent leakage. There

were four machines that BJB had developed to mix the material as it was pumped out. It took about twelve hours to fill it, with two machines pumping non-stop.

Then we noticed that the level of the resin had started to drop. The resin had a cure time of three to four hours. It started dropping, and we didn't know what was going on. A moment of horror. We couldn't see what was happening inside. I actually crawled in through the top and looked down to try and see what was going on. We had to investigate what had happened, to see if there was still any way of re-surrecting the piece.

So we started to take off the outside and found that what had happened was that when we did the pour,

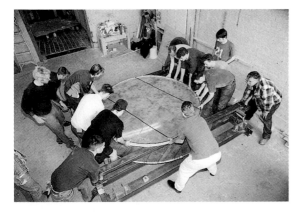 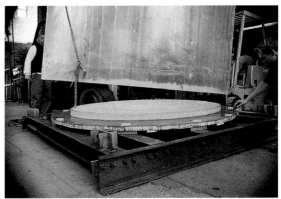

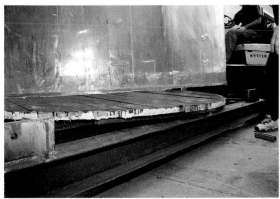 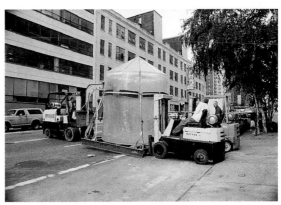

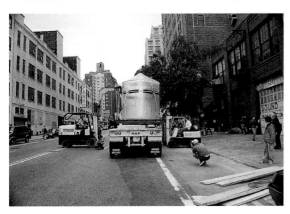 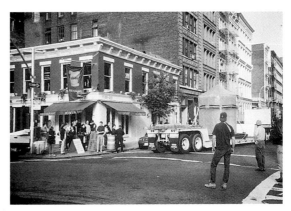

the core had imploded under the pressure and heat, and a lot of resin had spilled into the base of the piece. We had to hammer and dig and grind it all out, a hellish and unpleasant job which took a couple of weeks, working shifts. But we did manage to rescue it.

Then we had to bring it outside in order to cast the base. We moved it three or four times during the production process, which was a performance in itself.

We worked with a company called Mariano Bros., the Rolls Royce of movers, who worked with the cranes as if they were performing a ballet.

In the end we had used 9000 pounds of resin, but the piece finally weighed in at about 4 $^{1}/_{2}$ tons, due to all the waste material.

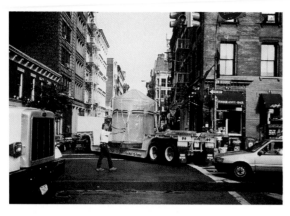
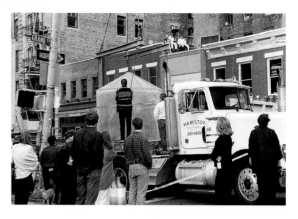
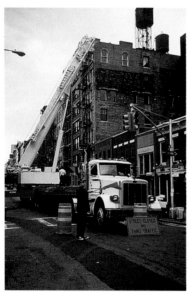
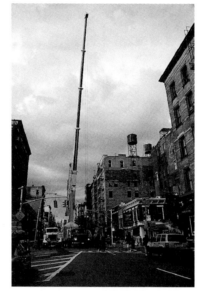
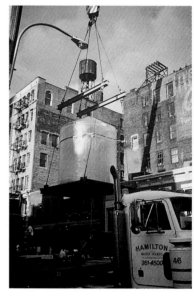
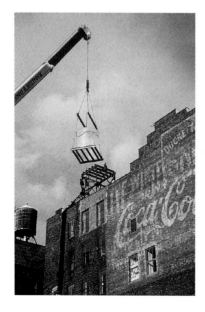
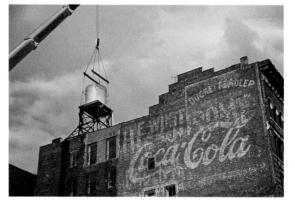

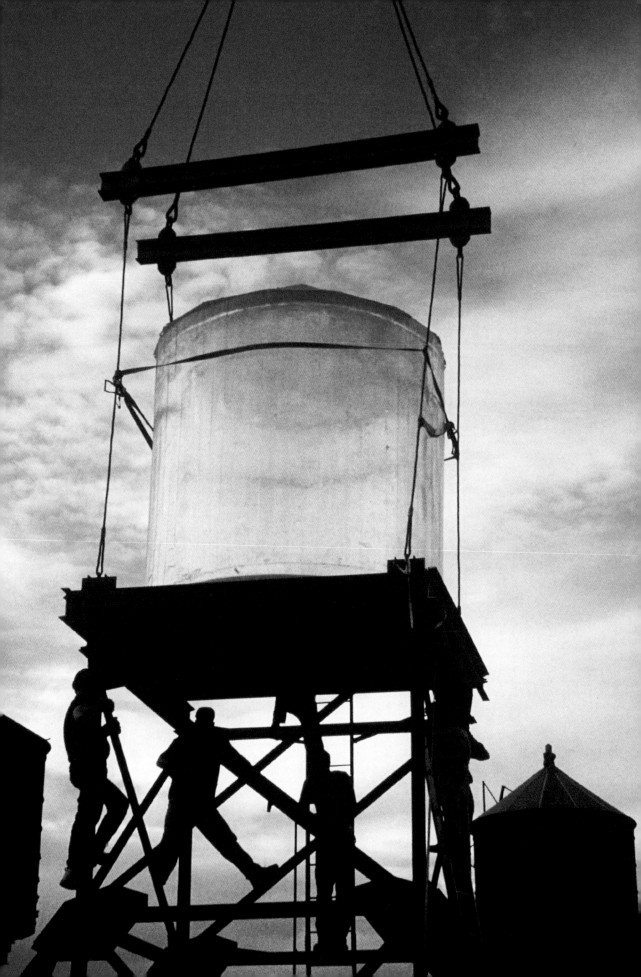

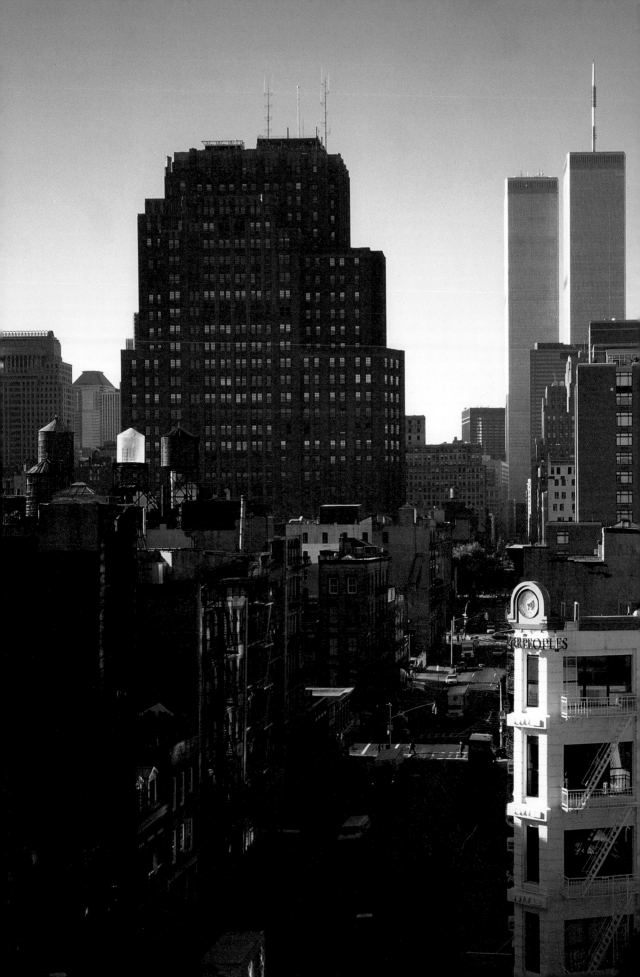

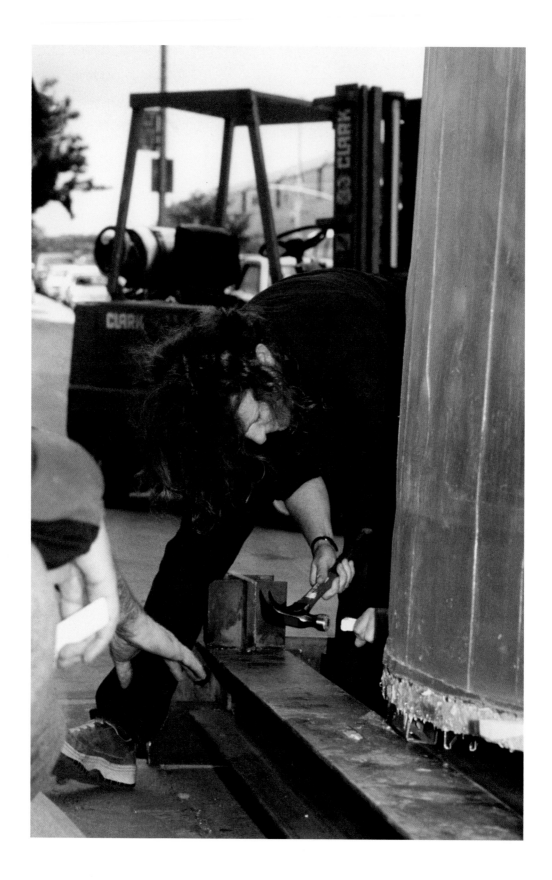

RACHEL WHITEREAD

Born 1963, London
Lives and works in London

AWARDS AND COMMISSIONS

1992
DAAD fellowship, Berlin

1993
House, commissioned by the Artangel Trust
 and Beck's, London
Turner Prize, Tate Gallery, London

1998
Water Tower, commissioned by the Public Art Fund,
 New York City

1999—2000
Holocaust Memorial, commissioned by the City
 of Vienna

SELECTED SOLO EXHIBITIONS:

1988
Carlile Gallery, London

1990
Chisenhale Gallery, London

1991
Arnolfini Gallery, Bristol
Karsten Schubert Ltd., London

1992
Luhring Augustine Gallery, New York
"Rachel Whiteread: Sculptures," Fundación Caja
 das Pensiones, Barcelona (cat.)
"Rachel Whiteread," Stedelijk Van Abbemuseum,
 Eindhoven (cat.)

1993
Galerie Claire Burrus, Paris
"Rachel Whiteread: Sculptures," MCA, Chicago (cat.)
"Rachel Whiteread: Zeichnungen," daadgalerie,
 Berlin (cat.)

1994
"Rachel Whiteread: Skulpturen / Sculptures,"
 Kunsthalle, Basel; ICA Philadelphia;
 ICA Boston (cat.)

1995
"Rachel Whiteread: Sculptures," British School, Rome
Karsten Schubert Ltd., London

1996
Luhring Augustine Gallery, New York
"Rachel Whiteread: Shedding Life," Tate Gallery,
 Liverpool (cat.)

1997
"Rachel Whiteread," Palacio de Velázquez, Museo
 Nacional Centro de Arte Reina Sofía, Madrid (cat.)
British Pavillion, 47th Biennale of Art, Venice (cat.)

1998
Anthony d'Offay Gallery, London (cat.)

SELECTED GROUP EXHIBITIONS:

1987
"Whitworths Young Contemporaries," Manchester

1988
"Riverside Open," Riverside Studios, London

1989
"Whitechapel Open," Whitechapel Art Gallery, London

1990
"British Art Show," international touring exhibition

1991
"Metropolis," Martin Gropius Bau, Berlin
"Broken English," Serpentine Gallery, London
"Turner Prize Exhibition," Tate Gallery, London

1992
"Doubletake: Collective Memory and Current Art,"
 Hayward Gallery, London
"Damien Hirst, John Greenwood, Alex Landrum,
 Langlands and Bell, and Rachel Whiteread,"
 Saatchi Collection, London
"Skulptur Konzept," Galerie Ludwig, Krefeld
"Documenta IX," Kassel
"The Boundary Rider: 9th Biennale of Sydney," Sydney

1993

"Passageworks," Rooseum Centre for Contemporary
Art, Malmö

"The Sublime Void: An Exhibition on the Memory
of the Imagination," Koninklijk Museum voor
Schone Kunsten, Antwerp

"Turner Prize Exhibition," Tate Gallery, London

1994

"Drawings," Frith Street Gallery, London

"Sense and Sensibility: Women Artists and Minimalism
in the Nineties," The Museum of Modern Art,
New York

"Seeing the Unseen," Thirty Shepherdess Walk, London

1995

"Double Mixte: Générique 2," Galerie Nationale du
Jeu de Paume, Paris

"Ars '95," Museum of Contemporary Art, Helsinki

"Brilliant: New Art From London," Walker Art Centre,
Minneapolis; Contemporary Arts Museum,
Houston

"New Art in Britain," Museum Sztuki, Lodz

"Carnegie International 1995," Carnegie Museum
of Art, Pittsburgh

4th Istanbul Biennial, Istanbul Foundation for
Culture and Arts

1997

"Sculpture Projects in Münster," Münster

"Sensation: Young British Artists from the Saatchi
Collection," Royal Academy of Arts, London;
Neue Nationalgalerie im Hamburger Bahnhof,
Berlin

1998

"Wounds," Moderna Museet, Stockholm

"Displacements: Miroslaw Balka, Doris Salcedo,
Rachel Whiteread," Art Gallery of Ontario, Toronto

"REAL / LIFE: New British Art," Tochigi Prefectural
Museum of Fine Arts; Fukuoka Art Museum;
Hiroshima City Museum of Contemporary Art;
Tokyo Museum of Contemporary Art; Ashiya City
Museum of Art and History

"Claustrophobia," Ikon Gallery, Birmingham;
Middlesborough Art Gallery; Mappin Art Gallery,
Sheffield; Dundee Contemporary Art Center;
Carwright Hall, Bradford

"Family," Nvisible Museum, Edinburgh

SELECTED PUBLICATIONS

1993

Rachel Whiteread, MCA, Chicago

Rachel Whiteread: Gouachen, daadgalerie, Berlin

Rachel Whiteread Plaster Sculptures,
Karsten Schubert Ltd. and Luhring Augustine
Gallery, New York

Rachel Whiteread: Sculptures,
Stedelijk Van Abbemuseum, Eindhoven

1994

House (limited edition), Artangel Trust, London

Lawrence Weiner and Rachel Whiteread, Parkett,
No. 42, Zurich

Rachel Whiteread: Sculptures / Skulpturen,
Kunsthalle Basel, ICA Boston, and ICA Philadelphia

1995

Excavating the House (VHS video and audiotape),
ICA, London

House, Phaidon Press, London

Rachel Whiteread: House (26 minute VHS video),
Artangel and Hackneyed Productions, London

1997

Rachel Whiteread, Museo Nacional Centro de Arte
Reina Sofia, Madrid

*Rachel Whiteread: British Pavillion 47th Venice
Biennale 1997,* British Council, London

Shedding Life, Tate Gallery, Liverpool

1998

Rachel Whiteread, Anthony d'Offay, London

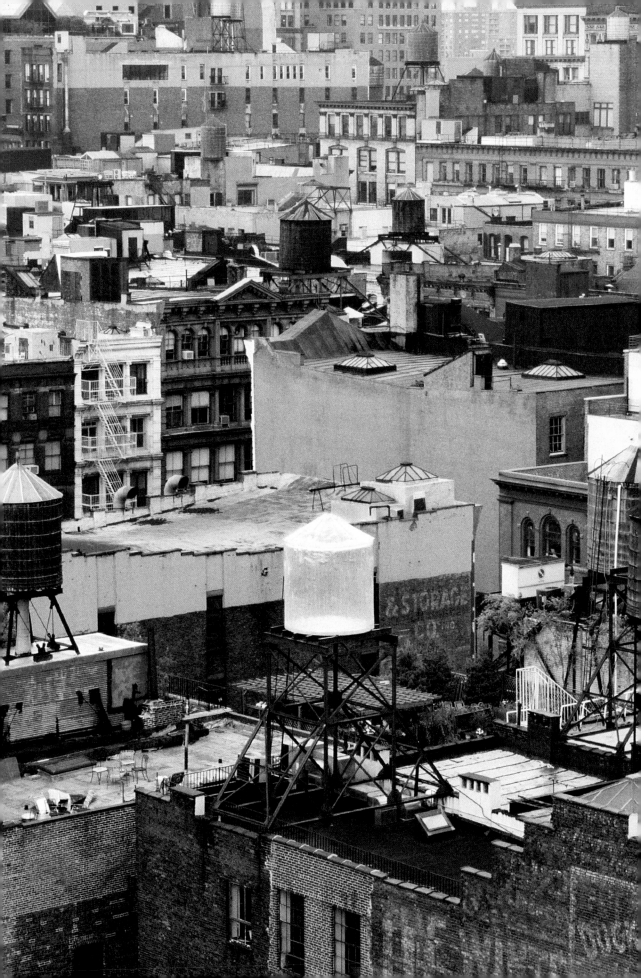

NOTES ON THE AUTHORS

TOM ECCLES is Director of the Public Art Fund in New York City. He moved to New York in 1993 from Glasgow, Scotland. While organizing exhibitions in alternative spaces and public venues in Scotland, he also taught at the Mackintosh School of Art in Glasgow. Since joining the Public Art Fund, he has organized exhibitions and projects by many artists including Magdalena Abakanowicz, Vito Acconci, Ilya Kabakov, Barbara Kruger, Tony Smith, and Andrea Zittel. He lives in Brooklyn, New York.

LOUISE NERI is an editor and curator who lives in New York City. She is a project associate of the Artangel Trust in London, and consulting curator for the Sydney Biennale 2000. She was U.S. Editor of *Parkett Magazine* from 1990—99, during which time she co-curated the 1997 Whitney Biennial and "Roteiros. Roteiros. Roteiros. Roteiros. Roteiros. Roteiros. Roteiros," the contemporary international exhibition of the 1998 São Paulo Bienal. In 1996 she edited *Silence Please! Stories after the works of Juan Muñoz,* published by Scalo and the Irish Museum of Modern Art.

MOLLY NESBIT teaches art history at Vassar College and is a contributing editor of *Artforum.* She has also written essays on contemporary art for selected international art periodicals *(Parkett, October),* books and exhibition catalogues. Her first book, *Atget's Seven Albums* was published by Yale University Press in 1993. *Their Common Sense,* her book about the industrialization of modern art and visual culture, will be published in 2000 by Black Dog, London. She lives in New York City.

LUC SANTE is the author of *Low Life: Lures and Snares of Old New York* (Farrar, Straus & Giroux, 1991; Vintage, 1992), *Evidence* (Farrar, Straus & Giroux and Noonday, 1992), and *The Factory of Facts* (Pantheon, 1998; Vintage, 1999). He has written on literature, photography, film, art, popular music, and social history for many periodicals, most regularly and consistently the *New York Review of Books.* In 1997 he received an Award in Literature from the American Academy of Arts and Letters, and in 1998 a Grammy Award, for liner notes. He teaches at Bard College and the New School. He lives in Brooklyn, New York.

NEVILLE WAKEFIELD owns five hundred square feet of leach field in the upstate Catskills watershed. On the return journey to New York City, he likes to ponder the flow of bodily waste and human endeavor. His first book, *Postmodernism: The Twilight of the Real,* was published in 1990 by Pluto Press, London. He has written extensively on contemporary art and photography for selected international art periodicals *(Parkett, Frieze,* and *Artforum),* books and exhibition catalogues. In 1996, he co-edited *Fashion: Photography of the Nineties,* published by Scalo. He lives in New York City.

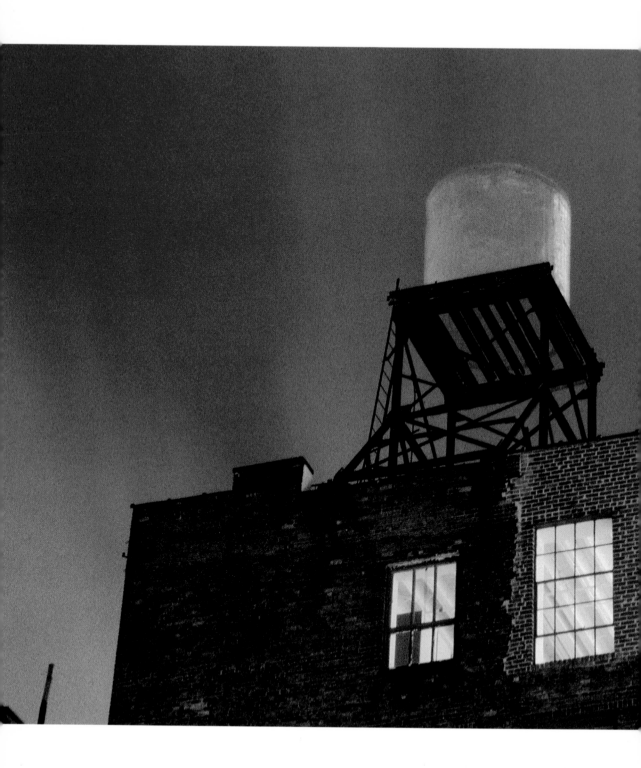

ACKNOWLEDGMENTS

RACHEL WHITEREAD, *WATER TOWER* (1998)
Grand Street at West Broadway, SoHo, New York City
A project of the Public Art Fund

Director ..Tom Eccles
Project Manager Gregor Clark
Research ... Greg Sholette
Development and Events Laura Raicovich
Press .. Lynn Richardson

Fabricator Charles Hickok

Studio Assistants Sullivan Walsh, Mark Williams,
Mark Van Cauwenbergh

Water tank provided by........................ American Pipe and Tank
Company, New York City: Richard Silver, Steven Silver,
Brendan McKenna

Engineering Hage Engineering, New York City:
Mark Hage, Solmi Gim

Resin production BJB Enterprises, Tustin,
California: Brian Stransky, Terry McGinnis,
Fred Van Dorp

Rigging Mariano Brothers, Danbury, Connecticut:
Joe Mariano, Frank D. Mariano, Jay Merrick, Ron Kayser

Crane Operator.. Hamilton Cranes:
Ronnie DeMarchis

Rooftop location at 60 Grand Street provided by........................
Joe Bierne and Catherine Tice, Ellen Weissbrod,
with the special assistance of Brenna Bierne

Photo Documentation Marian Harders

Computer visualizations provided by..
Walkabout Visualization Resources, New York City:
Steven Dean and Iris Benado

Special Permits.. Agouti Construction:
Jacqueline Mosca

SPECIAL THANKS TO
the many studio assistants who worked late into the night.

Thanks also to Jennifer Raab, NYC Landmarks and
Preservation Commission and Anthony Oddo, Department of
Buildings, New York City

WATER TOWER IS SPONSORED BY:

AND FUNDED BY:

The Silverweed Foundation
The Fifth Floor Foundation
Agnes Gund and Daniel Shapiro
The Charles Engelhard Foundation
The Andy Warhol Foundation for the Visual Arts
The New York City Department of Cultural Affairs
Cultural Challenge Initiative
New York State Council on the Arts, a State Agency

WITH ADDITIONAL SUPPORT FROM:

Sandra Deitch, Joel and Zoe Dictrow,
Arthur A. and Carol Goldberg, Patricia and Morris Orden,
Mr. and Mrs. Rudolf Schulhof, and Lea Simonds

SPECIAL THANKS TO:

Roland Augustine, Michael Bloomberg, Anthony d'Offay,
Anne d'Offay, Charlene Engelhard, Anthony Fawcett,
Karen Freedman, Nina Freedman, Patti Harris,
Wynn Kramarsky, Sarah-Ann Kramarsky, Lawrence Luhring
and Marcus Taylor

THANKS ALSO TO:

Matthew Barney, Peter Chater, Jennefer Eccles,
Peter Fleissig, Mark Fletcher, Alex Hartley, Tania Kovats,
Rachel Inman, Eve MacSweeney and Kiki Smith

PHOTOGRAPHIC CREDITS

Peter Fleissig, front cover, p. 151, 155, 160, 163, 167, 177, 185, 193, back endpapers, back cover

Rachel Whiteread, p. 2–8, 110, 139–140, 141 top left and right, 142, 143 top left and center, bottom center, 144 top left, 145 bottom left and right, 146 top left and center, 147 top right, middle right, bottom left, 148 middle center, 155

New York Public Library Picture Collection, front endpapers, p. 19, 29, 88, 91, 93, 95

Richard Prince, p. 12

Dorothy Zeidman, p. 20

Jennifer Kotter, p. 23

Estate of Gordon Matta-Clark, courtesy David Zwirner Gallery, New York City, p. 24

Hage Engineering, New York City, p. 30–33

W. H. Lawton, p. 88

Life Magazine © Time Inc., p. 96

Postcards, p. 98, 121 top left, top right, 130 top right, 134, 135 top left, bottom left, bottom right

Eliot Porter, *Antarctica* (New York: E. P. Dutton, 1978), p. 113 top left

Vincent J. Schaefer and John A. Day, *Atmosphere: Clouds, Rain, Snow, Storms* (Boston: Houghton Mifflin Co. 1981), p. 113 top right, bottom left, bottom right, 114, 115, 116 top left, top right

David Bourdon, *Designing the Earth — The Human Impulse to Shape Nature* (New York: Harry N. Abrams, Inc., 1995), p. 116 bottom left

Peter Haining, *Ghosts — The Illustrated History* (London: Treasure Press, 1974), p. 117, 118 top left, top right

By a Well-Known Physician, *The Wonderful Story of the Human Body* (London: Odhams Press Ltd., 1938), p. 118 bottom left, bottom right

F. E. Newing and Richard Bowood, *The Ladybird Book of the Weather* (London: Wills & Hepworth Ltd., 1962), p. 119

Mary Somerville, John Murray, *On Molecular and Microscopic Science*, vol. II, 1869, p. 120

Robert Rickard, Richard Kelly, *Photographs of the Unknown* (London: New English Library, 1980), p. 121 bottom left, bottom right, 122 top left, top right

Brian John, *The World of Ice — The Natural History of the Frozen Regions* (London: Orbis Publishing, 1979), p. 122 bottom left

Wonders of the World — A popular and authentic account of the marvels of nature and of men as they exist today (London: Hutchinson & Co. Ltd., 1933), p. 122 bottom right, 123, 124 top left

Paul Simons, *Weird Weather* (New York: Warner Books/Little Brown & Company, 1996), p. 124 top right

James E. Wheeler, *The Practical Handyman* (London: Odhams Press Ltd., 1938), p. 124 bottom left

W. Jerome Harrison, *Geology* (London: Blackie & Son, 1889), p. 124 bottom right

R. C. Honeybone & B. S. Roberson, *The Southern Continents* (London: William Heinemann Ltd.), p. 125 top left

André Guex, *Léman — 81 photographies inédites de Bénédikt Rast* (Lausanne: Éditions Jean Marguerat, 1947), p. 125 top right

Bill Cater and Shirley Crabtree, *Sunday Times Book of Do-It-Yourself* (London: Book Club Associates), p. 125 bottom left

Anthony Burgess and the editors of Time-Life Books, *New York* (Amsterdam: Time-Life Books), p. 125 bottom right, 126 top left, top right

Philip J. Lawson, *Practical Perspective Drawing* (New York and London: McGraw-Hill Book Company Inc., 1943), p. 126 bottom left, bottom right, 127 top left, top right

R. P. Brady, *Our Own World* (Huddersfield: Schofield and Sims Ltd.), p. 127 bottom left, bottom right

Mrs. Ray Homer, p. 128

The Royal Meteorological Society, p. 129 top left, top right, 130 bottom right, 133

Helping Daddy to Mend Things (further details unknown), p. 130 top left, 132 bottom right

Delpool Picture Library, p. 135 top right

Mike Bruce, p. 141 bottom left

Marian Harders, p. 143 top right, bottom left and right, 144 top right, middle left and right, bottom left and right, 145 top left and right, bottom center, 146 bottom left and right, 147 top left, middle left, 152, 156, 164

Tania Kovats, p. 146 top right, 147 bottom right, 148 top left and right, middle left and right, bottom left and right, 149

Alex Hartley, p. 158

Andy Warhol Museum, Pittsburgh, p. 170

Electronic Arts Intermix, New York City, p. 172

Peter Moore, p. 173

Courtesy Louise Bourgeois, New York City, p. 181

Babette Mangolte, p. 187

Lucas Michael, p. 196

Louise Neri — LOOKING UP
Rachel Whiteread's Water Tower

Editing: Louise Neri
Design: Hans Werner Holzwarth, Berlin
Editorial coordination for the
Public Art Fund: Laura Raicovich
Editorial assistance and
photo research: Elizabeth Horowitz
Copy editing: Alexis Schwarzenbach
Scans: Gert Schwab/Steidl,
Schwab Scantechnik, Göttingen
Printing: Steidl, Göttingen

© 1999 for the illustrations the artists
© 1999 for the texts the authors
© 1999 for this edition: Public Art Fund,
1 East 53rd St., New York NY 10019,
phone 1 212 980 4575

Distributed by
Scalo Zurich — Berlin — New York;
in North America by D.A.P., New York City;
in Europe, Africa and Asia
by Thames and Hudson, London;
in Germany, Austria and Switzerland
by Scalo.

Scalo head office: Weinbergstrasse 22a,
CH-8001 Zurich/Switzerland,
phone 41 1 261 0910, fax 41 1 261 9262,
e-mail publishers@scalo.com,
website www.scalo.com

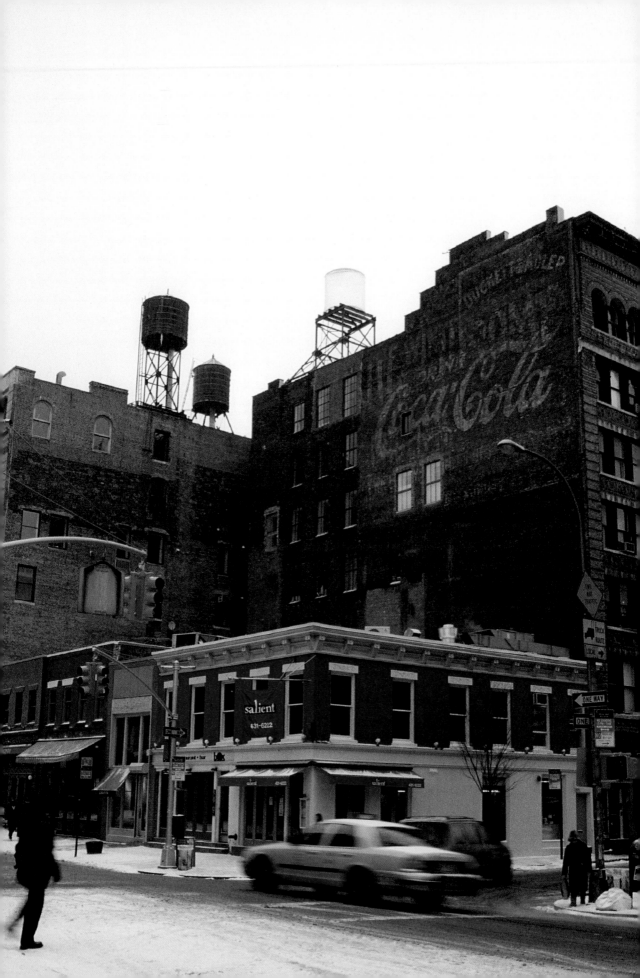

Commentary

Compiled and edited by Louise Neri

"Caught beneath the landslide is the champagne supernova in the sky ..." is a line from a song by Oasis. Water Tower is a champagne supernova in the sky, and Rachel Whiteread certainly was caught beneath the landslide with House, then later with the Viennese proposal. She didn't want to create any kind of controversy in New York, and so found a way to get out of the way, yet totally stand out. If you look at her water tower you can see about eleven others. But this is the albino, a translucent, beautiful, glistening salamander. Like all artists, she's drawing attention to herself, in a gun-shy sort of way.

—Jerry Saltz, Village Voice art critic

I have quite a complex relationship with public sculpture, and I really wanted to make something that was more like an intake of breath. Night is my favorite time for the piece, because it lets you know it's there. Or you wouldn't see it at all. It's just this tiny smudge in the darkness. There is no access to the piece. You cannot go up to see it; you can only see it from the street. The people who live in the house have had people ringing their buzzer, even though there is a sign saying "No roof access." They've had people getting up on the roof, and others leaping over from other rooftops to go and have a look at it. But really I think it's quite a discreet thing.

—Rachel Whiteread

I like the fact that there isn't any signage, that it doesn't declare itself. It's for the people who happen to see it and wonder what it is.

—Anonymous passerby

For me this is a model work, the best example of how an object "works" in the surrounding context, moreover in a context that is not speculative but rather physically presented. In this case, Rachel employed the device of the "White Crow." There are black crows everywhere, and then there is this one white one. In fact, anyone knows and can see by looking up that in New York, the tops of all buildings are equipped with wooden cisterns, as though they formed an enormous flock of strange birds that have landed on the rooftops. And, just like birds in a flock, they are all virtually the same, old, with weathered sides. Water Tower works as a contrast against the background of this whole ugly mob: it is very light, transparent, shining from within, a small riddle, an incomprehensible miracle. But in order to see it, you have to crane your neck and look upward, and it is hard to count on this in the busy hustle-bustle of New York.

—Ilya Kabakov, artist, New York City

I don't look up. If you look up in New York, people think you're a tourist. If you are preoccupied with what's going on up there, then you make yourself vulnerable on the street.

—Anonymous passerby

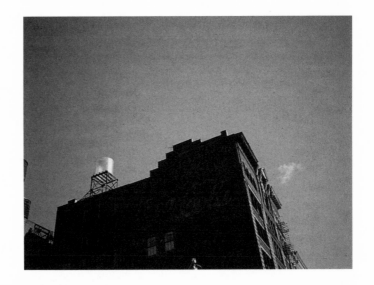

I read it as the process of finding a site, by which an element can be precisely cast and replaced and then transformed in materiality. Whatever this metaphor is, it has tremendous possibilities as an architectural urbanistic act. This is where it becomes radical. She has moved it out on to the chessboard of the city, so now the question is, who takes up that challenge? It creates the ability to make existing elements fictional. And that's a very big step for Manhattan, because it has to do with authenticity and the casting of one thing off another, then the resiting and transformation of it. She asks how one can fictionalize aspects of Manhattan and yet keep them authentic.

—Diane Lewis, architect, New York City

It's a beautiful piece, silent, ghostly, responsive to changing light and so fused with its site that it becomes a fitting memorial to the neighborhood itself. Elevated on its own platform, it is flanked by several nearly identical versions of the real thing, to which it relates just as a translucent, freshly shed snakeskin relates to a snake.

—Roberta Smith, art critic, The New York Times, August 27, 1998

I've always associated Rachel Whiteread with concerns of social space so it interests me that Water Tower doesn't relate to space that bodies occupy. It doesn't seem to elaborate on the wider concerns of her earlier work, but rather to apply the same procedure in a way that deterritorializes our understanding of what it is about. It makes me think that her work might not be "about" something, so much as what it does; that it's a practice which has ramifications without being structured to generate a particular reading. It's not representing something in order that we read it; it's rather applying a process to quite literal effect.

—Robert Leonard, curator, Artspace Auckland, New Zealand

BJB is a custom formulator of specialty resin systems. We will look at projects and see if there is some means by which we can help people do things by altering our systems chemically or with processing equipment. The former director of the company was very responsive to new ideas. He had built the company based on his knowledge of the aerospace industry. We've done a lot of unusual things in aerospace, but none of it is visible, it's all part of something else, like high-impact windshields. Prior to Water Tower, we had ten years' experience working with our Water-Clear rigid plastic material to make very large castings. Around 1979-80, there was a movie for which we successfully cast a very large mass of material like an ice cube, with a girl inside. Then we did some industrial projects that were as large or larger. That led us to helping to cast a figure of a Native American Indian for the Foxwoods Casino. That was a 5800 lb. pour in a single cast. We handled that from A to Z, from equipment to supervision of the casting. We also furnish material for special effects—for example, artificial icicles for the entertainment industry—using a "sister" material to the resin used for Water Tower.
　　　　　—Brian Stransky, Managing Director, BJB Enterprises, Tustin, California

Water Tower involved taking on the idea as much as taking on the job, and there was a lot of improvisation involved.
　　　　　—Mark Hage, structural engineer, Hage Engineering, New York City

It's a water tower but it's sculpture—try and explain that to the building department. Telling somebody that something is art is so nebulous. I had been told by the Commissioner's Office to file Water Tower as a sign in order to get it approved. I knew it wasn't a sign and I knew it didn't indicate the building in terms of what you think of as a sign, but there was no other avenue to file it under. This is probably the first one of its kind that has ever come through the city like this.
　　　　　—Jacqueline Mosca, permit expeditor, Agouti Construction, New York City

It's more like a public image than a public sculpture, isn't it? I mean, you can't get up there, can you?
　　　　　—Anonymous passerby

The idea of a suspended solid removed from its casting is an amazing idea. Water Tower entered into another realm: that the memory of something could become solidified and transformed. This idea has a lot of possibilities for reading the city. Obviously the tower oscillates between being a solid and a drawing, which is very successful, particularly because you can usually walk around her sculptures. In this case you can't, so it's transforming itself into a drawn image, a public image, a drawing in the sky.
　　　　　—Diane Lewis

Do you have to pay to get in?
　　　　　—Anonymous passerby

The whole strategy of moving towards transparency has always been associated with notions of revelation, enlightenment, and so on. In that sense, Rachel's work is about revelation and "seeking the truth." There is a confluence between the artist's intention and the architect's intention. The timing is notable. It's hard for me to disassociate any of the people who are working vaguely parallel with a shared sense of values about how things represent themselves, isolating various phenomena then using other media to bring them forward.

—Terence Riley, curator, Department of Architecture and Design,
Museum of Modern Art, New York City

In the film Predator 2, an alien drops in on Planet Earth to hunt humans, using a hi-tech cloaking device that renders it transparent. A human detective, who's chasing it over the rooftops, only sees it when he's not really looking for it, when he's looking awry. Then it appears as a form of luminous distortion, an interference pattern in the way the world is supposed to look. Like the Predator, Water Tower is hard to see; it almost disappears in some light conditions, it doesn't announce itself. The resin is a sci-fi, techno, synthetic material, fitting the current vogue for see-through boots and iMacs. It's like a replicant, an alien water tower, lurking within a population of human towers. It doesn't announce itself as an art-work. If I had just stumbled across it, I'd have been majorly confused. I might have had an X-Files experience, I might have thought that perhaps those water towers aren't full of water at all.

—Robert Leonard

What I really enjoy about Rachel's work is that it is bordering on the issue of whether an artist could actually use design-tooling techniques to produce objects that are less labor-intensive, less hands-on, more robotic, more tool-oriented.

—Karim Rashid, industrial designer, New York City

Water Tower hovers in a mid-compass of time, not space, where you can see both the past and the future of SoHo. It is like a piece of digital information on a light-filled screen, as opposed to earlier representations (photographs, paintings) which are like images of the word—Gutenbergian so to speak—in that they are frozen, opaque, somewhat eternalized images. That you can never see it in its entirety again has an internet reference to me. For every image you see you are aware that there are a million possible links or networks.

—Jerry Saltz

This material is used for special effects, to look like something else under the camera. In this case, it was intended to look like water up in the air. Some people think it's ice. I see black as black and white as white. I wonder how artists come up with these ideas. I guess art is about seeing differently. I don't really know the difference between art and special effects.

—Fred Van Dorp, Production Manager, BJB Enterprises

Andy Warhol, still from *Empire* (1964)

Huge wooden buckets holding water for the city—water towers have always been un-modern and inadequate. In a city of glass and concrete, woodiness on roofs is like a country in the sky. High up, perched on legs, water towers have always looked pre-carious to me, about to topple. The transparency and ghostliness of Whiteread's work makes me realize how filled with metaphors the water towers are, each one standing alone against the world, soldiering on, doing its job. Containers of fantasy, not water. This negative-space twin even offers evidence of an anti-universe, one of millions of unavailable worlds. Then I look again. I imagine Warhol's Campbell's Soup Can, Brillo Box, Empire State Building. It's Pop Art sculpture, wry and cool.

—Lynne Tillman, writer, New York City

Ninety-nine percent of all public sculpture is shit. The reasons for this are com-plicated and many, coming from the madness of not knowing where art is and what it does. Water Tower is the exception. I think it is the best piece of public art in the United States right now. Water Tower is invisible and it should stay that way. It raises a bar that shouldn't be seen.

—Jerry Saltz

The opposite of Water Tower is everything that is in front of every building in town and some of it's good and some of it isn't. Only David Hammons has really made something that is at once so dramatic and so discreet, with Higher Goals (1990). Rachel's piece is also a very big gesture. It's completely integrated in the landscape and it makes perfect sense, yet it has been put there, it didn't come from there.

—Robert Storr, curator, Department of Painting and Sculpture,
Museum of Modern Art, New York City

It reflects the idea of a monument without marking a site that a monument would normally mark as being significant. It is an empty form waiting for meaning to attach itself to it.

—Robert Leonard

My interest in public art goes back to 1972 when I wrote the position paper on works of art in public places for the National Endowment for the Arts. That program put over 300 works of art in public places. The one that shut the program down was, I guess, Serra's Tilted Arc. Anything out there in public that really makes an impression and also contributes to the identity of a site is of enormous interest to me. I look down over SoHo from thirty storeys up; the whole section is actually identified by the water towers. I was astonished that Rachel Whiteread made a public work which calls attention to the visual identity of the roofs here. I found that marvelous.

—Irving Sandler, art historian, New York City

The street corner it is installed above has four restaurants; it looks like a European square. Something European happens when you go there and then try to find it—which is curious. I'm not sure if that was intended.

—David Zwirner, SoHo gallerist

I never thought of Rachel Whiteread as a foreigner, but rather as a careful, cosmopolitan observer of the street she walks in.

—Irving Sandler

At first I was disappointed with it because I found out that it was made off site, then hoisted up and put in place; I thought that Whiteread would cast it on site, not realizing that in fact this would have been logistically impossible. In the end, it led me to a greater appreciation for the mystery and the artifice of art, art's ability to do things that normally can't be done.

—Kirby Gookin, art historian, SoHo resident

We also had to deal with the fact that the sculpture had to be cast in a studio. We had to follow it around, making sure it didn't go through the ground. We had to design how it was lifted, how it was supported while it was lifted, how to roll it out of the studio. The entire garage had to be reinforced. We had almost to imagine how it would be cast, where it would be sitting, how it would be rolled, and follow the structure and reinforce the path of this thing, as if it was a hurricane.

—Mark Hage

I had a big preoccupation with rooftops in the 1970s, about getting up to this other plateau that is always visible, always right with us, but not often acknow-ledged—a plateau of possibilities, of horizontal communication that was available but that no one was using. I was fully aware that people didn't look up; artists probably did, but there weren't that many artists when I was living downtown and doing this. I couldn't afford to work in a theater, I wasn't being invited to work in theaters, so the rooftops provided a solution.

—Trisha Brown, choreographer

When I most recently saw Rachel Whiteread's Water Tower I had, serendipitously, just viewed Gordon Matta-Clark's short film of 1973, Clock Shower in which the artist, suspended on the hands of the large clock atop the building of Leonard and Broadway in lower Manhattan, cleans himself under a hose poked through its works. Matta-Clark's performance was only a few blocks away from Rachel's piece, albeit separated by twenty-five years. Perhaps it is a poetic coincidence: two young sculptors on the top of buildings in New York, transfixed by water.

—Richard Armstrong, Director, Carnegie Museum, Pittsburgh

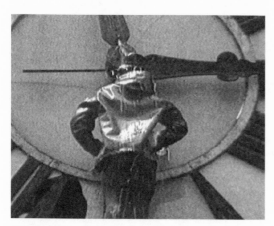

Gordon Matta-Clark, stills from *Clock Shower* (1973)

Previously we'd worked with people experienced in special effects. The budgets were higher and allowed for greater contingency. This project did not allow for failure. There was a real deadline with the building permits and budgetary limits. So that was a big psychological obstacle because there was a lot riding on its success. It was the largest project the Public Art Fund had ever done, and the biggest resin cast of this kind ever made. A major project on any level. It's about doing the impossible in tough conditions, as much about optimism as anything.

—Brian Stransky

Most works of art in public places are not confrontational. They are rather benign and people may object at first but then get to love them, such as the Alexander Calder in Grand Rapids, which became the trademark of the city. One of the beautiful things about the Whiteread piece is its responsiveness to the changing light which sets up a whole new visual and, indeed, expressive register.

—Irving Sandler

Then I had the same thoughts looking at the real thing that I had had while being examined by the Building Department to obtain the permit for it. OK, so where do I put this in my world?

—Jacqueline Mosca

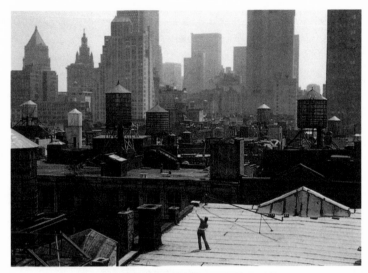

Trisha Brown, *Roof Piece*, SoHo, New York City (1972)

For Roof Piece, people were stationed from the Castelli Gallery on Broadway to
White Street in Tribeca. That's about twelve blocks. People were up on the roofs;
you could see them sunbathing and hanging out. We took one gesture and passed it on
down the line across the rooftops. It transformed as it traveled. Like the game of
telephone, it was very much about communication. Recognize that this was a time in
which we were living illegally: I and many of my friends had absolutely no money;
just to have a telephone was a cost. So to be able to transmit a message over
twelve buildings was to overcome very real obstacles. This rooftop communication
cost nothing and made no sound.

—Trisha Brown

This public monument is Anti-Heroic. To juxtapose: public sculpture that is
Heroic: Walter De Maria's Lightning Field. Maya Lin's Vietnam War Memorial. Richard
Serra's Tilted Arc. To give credit: Whiteread deftly continues the tradition of the
Anti-Heroic.

—Sam Samore, artist, New York City

Either you see it or you don't, or you either get it or you don't. Its unlike tra-
ditional public sculpture—more haunting, more fragile, more fleeting, more
respectful.

—Burt Barr, artist, SoHo resident

It has a totally different effect than her other work, and very different spatial
consequences. I read it as the possibility of an element in the city being replaced
by its inner self, as an unprotected, vulnerable condition, completely trans-
formed from the original as a physical object. It's a whole new subject matter.

—Diane Lewis

173

Whiteread's work always makes me think about forensic evidence. Her domestic loca-
tions are places where murders happen, in baths, under beds and floors. There
is a proximity with death. In so many thrillers, chases happen across rooftops,
suicides off bridges or . . . in water tanks. So maybe she is drawn as much by the
insidious potential of objects and places as by their charm.

—Anonymous

"[T]hree years ago a water tower above a large tenement ... was struck by light-
ning. The tower was the highest structure in the neighborhood, and the event was
perfectly explicable, if slightly unusual. When the building's residents and fire
department reached the roof, however, some were inclined to view it as a providen-
tial event—for the tower contained the bodies of a pair of children. A brother
and sister. Their throats had been cut. ... The bodies were in an advanced state
of decomposition when they were found. The boy's had fallen off an interior
platform on which they were originally placed, and into the water. It was badly
bloated. The girl's was somewhat more intact for having stayed dry. ... I never saw
anything more than the official reports, but I did note one curious detail from
those." [Kreizler] pointed with his left hand to his face. "The eyes were gone."
. . .
Roosevelt [declared,] "That's not uncommon. Particularly if the bodies were ex-
posed for a long period of time. And if the throats were cut, there would have
been plenty of blood to attract scavengers."
"Perhaps," Kreizler said ... "But the water tower was enclosed, with the exact pur-
pose of keeping scavengers and vermin out."
. . .
"But," I protested, "the water tower or building doesn't exist that can keep certain
animals out. Rats, for instance."

—Caleb Carr, The Alienist, pp. 63-64 (New York: Random House 1994)

I find the water towers completely strange because we've got nothing like it
where I come from. It surprised me to learn that water tanks are still in use
because whenever I come to New York I always think of them as some kind of hang-
over from the smoke-stack era of industrialism. So I figured Whiteread's use of a
water tank probably had to do with the historical and political textures that were
made visible in House. Water Tower operates in a very different way, more like a
Platonic ideal applied to a volume of liquid.

—Robert Leonard

I like the idea of elements in the urban landscape being transformed, and taking you
completely by surprise. That cities can be transformed by redefining certain ele-
ments through subtle cuts, slices, castings, embedments, transformations is what I
consider to be the most interesting possibility in architectural urbanism now, as
opposed to post-war planning. Although Water Tower is sealed, it provokes me to ask
that when something solid and impenetrable is transformed into a translucent, hol-
low element, could it also have another program? Could it be an inhabitable space?

—Diane Lewis

Gordon Matta-Clark used to live in the same building as me. He'd invite his friends over for a sauna, then they'd rush up to the roof and jump in the water tank to cool off.

—Clarissa Dalrymple, SoHo resident

Water towers look like the typical stick constructions of northern forest countries that have an abundance of wood. But then again, you could say that they are like boats. It reflects the kind of architecture that has to resist the flow of water and be buoyant and portable and so on. The form probably arose out of extreme pragmatism: what works. In that sense it's a very American solution. Its construction, smaller planks of wood banded together, probably has to do with the fact that they have to be taken up the stairways and assembled on the roof. Most of the time they were hidden so the architects didn't care about what they looked like anyway.

—Terence Riley

Water Tower is getting into architectural dimension, not just in terms of ambition, but in terms of form—using what is available. That possibility has made this time an interesting one for me to live in.

—Richard Artschwager, artist, New York City

In general, public art is very much a public event in the path of the audience, as if to justify itself in terms of the resources spent on it, it has to be in full display all the time. So to do something that is this discreet, that you can discover when your mind is wandering and you are looking away from the world is a lovely change from that other habit. And Water Tower is very much a public piece because it's available to everyone when they are not paying attention to the big events of the city. Its ambiguity is like a thought balloon waiting to be filled.

—Robert Storr

There are so many things competing for your attention in New York. I don't look at it and I doubt that many people do. Even if you tell them to. People's attention spans are just so incredibly short here.

—Anonymous passerby

I don't think there is enough public art in a city where everyone is on foot. Where can I go and look at something beautiful? Every square inch of New York is turning into a building. We're losing the few gardens that we have. There is a lot of open space here, but even that is disappearing. I think Water Tower is a very interesting answer to a problem that all New Yorkers are aware of; it acknowledges that the sidewalks are crowded, that it's busy, that there is not a lot of space in which to put things. As a project it is something to believe in because it has created a discussion.

—Jacqueline Mosca

I think because it's placed in the public realm you also have to look at how a gene-
ral public will react to it, and those sentiments, those emotions are out there and
they're real and they're fine. If some tourist walks down there and sees it and
says, "I'm going to start looking at these water towers. I always thought they
were special but didn't really know they were special until somebody else made them
special." I think that's great. Everybody can look up and see it and react.

—David Zwirner

Water Tower is not public sculpture. I would call it a private sculpture in public
space. That seems like a good solution to me.

—Jerry Saltz

Even when public sculpture isn't meant to be "man-on-horse," it still is. But this
isn't. It's available to the public; it sneaks up on people. It's a grand innova-
tion in this sense. Because it's not publicly accessible, yet publicly visible, it
doesn't create the resentment that most sculptures do. You can't touch it, but its
distance affords the viewer the discipline of looking as well as a sense of plea-
sure and beauty and mystery.

—Wynn Kramarsky, SoHo resident

For the average New Yorker, it's odd to think that so much money would be spent
hiring a consultant and a structural engineer, and so on, and the process of de-
signing it and installing it and so on. Compared, say, to how people in the Building
Department work, how they live, and what kind of projects they see every day. The
Building Inspector was amused by it, and amazed by what people do with money in
New York. There is such a disparity between people like him, who probably doesn't
own a car, and people like Rachel who can have a team of experts to make some-
thing happen for no other purpose than to make art.

—Jacqueline Mosca

Rachel's project differs from mine in that it doesn't deal with the city plan and
its history: Two Way Mirror Inside Cube and Video Salon at the Dia Center for the
Arts is about the 1970s and 80s; the penthouse, the slum roof, and the neighbor-
hood playground (because the rubber on the roof is used in playgrounds). I cen-
tered the two-way mirror cylinder on and gave it the same cubic dimensions as the
symbolic wooden New York water tower overhead. This symbolism was inspired by
Aldo Rossi's early drawings of New York City. When everybody was looking to modern
things, Rossi was looking to the archetype, the typology. New York grew up in the
nineteenth century, and Europeans see that New York is archaic.

—Dan Graham, artist, New York City

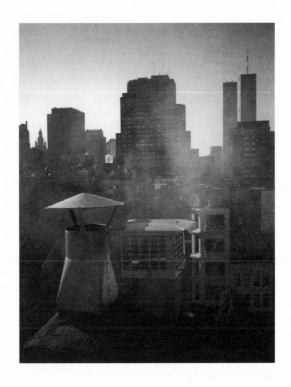

It's very sci-fi in the sense of being something that has "landed," something that is familiar, but which is made of unfamiliar material; something that just appears on the skyline or in a park. It is inexplicable: That's how it functions.

—Robert Leonard

Whiteread obviously shares a concern with Dan Graham in capturing a certain place in the urban landscape, and a fascination with the edicule.

—Terence Riley

The American Pipe and Tank Company started in the early 1900s. Originally it specialized in making steel tanks, but when I became more active in the business I moved it into different but related areas; wooden tanks were a natural evolution. In the original trade, which goes back to biblical times, the carpenters who built wine casks were called "coopers"—which is all water tanks really are. The evolution of New York City began down at the Battery. In those days, all the buildings were low-rise, so there was enough natural water pressure to get the water up to the roofs. As the city developed, so did the need for fire protection. At the time, technology was limited but there was an natural abundance of lumber and an endless supply of carpenters due to the flood of immigration. The wooden tanks were expeditious and efficient, given that the buildings they were intended for were almost completely built out of lumber also. Water Tower brings attention to an unique industry that is particular to New York more than any other city on the planet.

—Richard Silver, Director, American Pipe and Tank Company, New York City

The water towers and the fire escapes were Aldo Rossi's favorite things in Manhattan. They reminded him of medieval Italy, so there is a history of artists reading New York. Clearly, this special indigenous element of Manhattan has mythic characteristics, so for Whiteread to cast its interior and make it translucent—that the water is hovering there without its container—is a powerful narrative idea.

—Diane Lewis

Every day I watch it fade with the light until it becomes an empty space.

—Anonymous

I don't think a resin casting this large had ever been attempted. The only one we knew of shrank about six inches in the attempt. So right from the beginning we knew we were going into uncharted territory, just in terms of the materials alone. In terms of what the structure represents, it's a very well-known and ubiquitous landmark but it was unique because of the material and because it was a sculpture. I had worked on other art projects before from George Segal to Acconci; it's a completely different mindset than that required for buildings or bridges. You have to get into the shoes of the artist much more than you would have to with an architect because obviously artists aren't as concerned with function and behavior. They push the limits of what is possible. So it's another layer of complication for us. This project was like a Swiss watch. It had a lot of minutiae and required much more creativity than typical building structures which have their own set protocol.

—Mark Hage

This is a medium that needs to be reinvented and Whiteread has proposed a way to do it. The public sculpture has a whole set of challenging issues that one associates with the most advanced work being done in a gallery or a museum. And she's been able to take those issues out into public. I think it's a great achievement. Also how it explores the issues of what is real and what is illusion, issues that are at the core of what art does, to question levels of "reality," levels of expression. It prompts these and many other philosophical questions in addition to providing a strong aesthetic experience.

—Jeffrey Deitch, SoHo gallerist

Before I saw Rachel's piece, I imagined it as being somehow visible but see-through, and I was trying to work out what you would see if you saw through. When I look at it, I see mainly the platform, and the opacity of the material, which is the water. It's like a Swatch where you see the mechanism. Here the mechanism is the water itself.

—Trisha Brown

I had to learn as much as I could before we started. It's amazing how simple water towers are. Just a bunch of boards with some straps. Barrel-making on a large scale. Nothing high-tech at all. Understanding the construction taught us that we could use the tank as a mold for the resin, although it was something we would never normally do, because resin bubbles on contact with moisture. I spent six months playing with sealants. But it was difficult and always very risky.

—Chuck Hickok, fabricator of Water Tower

Water towers are probably not going to last forever, both the real ones and Rachel's. So this sculpture is prescient, a future-perfect ghost image. It is made to be seen from the street, hovering up there, intimating that personal futures really don't mean very much in the grand scale of things, in the city. This is something that is there, and it is beautiful; it'll be there for a while and then it won't.

—Wynn Kramarsky

Aliphatic polyurethane is a chemical term applied to the class of materials from which Water Tower is made. It is noted for its ability to handle outdoor environmental vicissitudes. It would take a lot to destroy or damage it because of its weight and thickness. If properly cured, it's extremely durable. To ignite it would take repeated exposures to temperatures above 600 degrees Fahrenheit with flame before it would even begin to burn.

—Brian Stransky

I guess they're there for the sprinklers ... but I dunno, I've never really thought about it.

—Anonymous passerby

It's strange and startling in a place like New York, which seems so completely made over, when little eruptions of the natural world, or whatever the life of the previous world has been, come through. It's the history of a natural resource in the city and a mapping of a vital circulatory system that people don't see. It provokes thought about where things come from. So, where does water come from?

—Greg Sholette, member of Repo History, a public art collective, and researcher for Water Tower

At the hydrant, water pressure of the New York system is 150-200 lb. per square inch. That's a lot. And consequently the pipes have to be in good shape to carry the pressure. When you get a building above a certain height, you have these wooden water tanks to accumulate water at a low rate of fill. Then gravity plus the natural water pressure is going to take care of the tank. As styles change, these tanks become offensive or non-existent, or if it's pure architecture there is no context and they don't exist. Maybe water towers will not disappear because the city is not going to want to tax the pipes.

—Richard Artschwager

Water Tower made me think about the New World and its relationship to the Old World. Every time I come back to New York from Europe, I see how different our architecture is. It isn't as cared for, it's entropic. There is an inherent dis-respect for the visual, yet if you look beyond that, you can see that things are constructed here in an ad hoc way that is almost more Third World. In the history of industrial development in the U.S. there is a workman-like fascination with the way things are put together. Beyond that, New York City has a stage-set quality in which everything is constantly falling apart. Looking out my window in the Wall Street district, I see the facade of a brownstone, the bottom of which has been converted into a Wendy's snackbar, painted fluorescent with a neon in the shape of an Ionic column. The only way I can tell it was originally brown is by the edge of the bricks; the rest of it has been painted black, including all the windows, some of which have been turned into vents. Then my main view is to the side of the building which is solid brick, except for the top which is slate and brick with vents, then giant, puffed-out fake bricks. There is something about this city's repeated cursory attempts to cover these facades, which get weaker and weaker as time goes by. This goes back to the Brechtian idea of theater where you are always becoming aware of the mechanism at work. In New York City, you want to know where things come from, to know the system, and that means looking backwards into any object that you have around you. The water tower demystifies the technology of faucets because you can see that the water is just held in big pots on the tops of buildings.

—Tony Oursler, artist, New York City

Prior to this project, we had gotten involved with a local public school's pro-gram for little children taking them on field trips to explain how the city func-tions: How does electricity get into your building? How does heat get into your building? How does water get into your faucet? I like this kind of public-spirited thing. Too often in business you are so driven to target clients and generate sales that there is no time to stop and try to understand how what you do affects the people around you. Possibilities such as Rachel's project give you the oppor-tunity to break the mold. So, when all these factors came together, I found it both challenging from a business standpoint and rewarding from an individual one. Maybe deep inside all of us is a frustrated theatrical individual waiting to break out!

—Richard Silver

We're taught not to see how things function. You see water towers and yet you don't see them, you ask what they are, you find out what they are, but you don't really know what they do. That was my interest in working with them; they were secret, invisible, and I could have them, work with them.

—Trisha Brown

I thought that this was probably the last piece made out of the environmental materials of SoHo to appear in SoHo. Back in the 1970s people worked in the streets, using industrial materials found in dumpsters, left over from the garment industry and shoemakers and so on. Now there is practically no SoHo left, so this is the punctuation mark of a 20-30 year run of art made out of the industrial setting of the city.

—Robert Storr

I don't think Water Tower is nostalgic at all. It's as much about sci-fi as the past. Futuristic. J.G. Ballard. She's made the inside of the tank visible, stripped away the historical, organic skin to reveal this artificially rendered mass. Like a cyborg presence. She is casting it in a material that didn't exist in the past, a very modern space-age material.

—Anonymous

When Louise Bourgeois moved from Paris to New York in the late 1930s, she was immediately enamored of the wooden water tanks of New York, seeing them as fantasy structures, hideaways. She was living with her husband and children in a small apartment. Because of the lack of space, she worked on the open rooftop of the building in which they lived. A sculpture from this period, Brother and Sister, was made using discarded timbers from a water tank. More than fifty years later, she revisited her early fascination with these structures in an installation entitled Precious Liquids (shown at Documenta IX), which consisted of a huge wooden water tank that she had salvaged from the rooftop of her Brooklyn studio installed with various biographical elements.

—Jerry Gorovoy, New York City

Louise Bourgeois, New York City (1944)

Cast and exposed in the negative by Whiteread, inner space can actually take place, showing haptic texture and the fabric of its architectonics. In Water Tower, the object is the reversible of the contained fluid substance. A "lacunar" metonomy for the city of New York, whose cityscape is a map of water towers, the lacuna-r texture is a filmic screen for the projected stories of "the naked city." Visiting Whiteread's translucid architecture, the passage of people through a brief moment in space shows the tense materiality of suspended historicity.

—Giuliana Bruno, cultural historian,
Department of Visual and Environmental Studies, Harvard University

I'm not an artistic person, so I can't talk about it as art—but it was one heck of a construction. It is an accomplishment not really of what it ended up to be but what it took to do it. It was a massive orchestration without any guarantee of success. Many of our competitors thought it couldn't be done, but we like that challenge. Now we can say that we can do a 9000 lb. cast; that the material can be controlled says a lot for the material and the chemist. I have seen a piece boil, and that's when you want to stand back.

—Terry McGuiness, Technical Sales Manager, BJB Enterprises, Tustin, California

I saw it out of my hotel window and I thought it was on fire the way it was catching the evening light. I had no idea what it was.

—Guest, SoHo Grand Hotel

I still perceive it through the memory of the process of it being made, which is perhaps the "curse" of the project manager. That you mistake the story of the fabrication for the piece, the engineering feats, the size of things, the problems, and so on. Ultimately these issues are irrelevant to one's perception of the finished piece. But this insider knowledge certainly had an impact on my ability to read the piece. Now, after almost a year, being able to stumble upon it and contemplate it is a wonderful gift. I am shocked by how quiet it is in its loud environment. This experience is in conflict with my recollection of it. So I feel like I have rediscovered it.

—Gregor Clark, Project Manager, Water Tower

I usually don't find out about where the end product goes. I'm just asked to make it. But with something of this magnitude, you get a bit more insight because it had to be specially devised; plus Rachel came here to do the tests. As far as the production of the material goes, knowing the magnitude of the project and how many batches have to be made, if we messed up on one batch in the middle of the pour, it could have been disastrous. There were thirteen 700 lb. drums of resin and thirteen of the hardener. As far as in-house quality control, we had to step it up for a project like this, because we knew it was going to be one massive pour.

—Fred Van Dorp

Rachel's piece is an absence, like George Segal's white sculptures; a ghost of a water tower that was there, or of what's going to come back again, or be useful at some future date that we don't know about yet.

—Richard Artschwager

Rachel Whiteread's barely-there water tower could be a crowning monument for Joseph Mitchell's Manhattan. Starting in the 1930s, Mitchell commemorated the city and its denizens in the pages of The New Yorker. Bypassing the obvious, Mitchell's eye ran towards the marginal and truly original New York for which he scouted high and low. He profiled the Native American high steelworkers, whose aerial ease helped build this city so characteristically skyward. He also wrote on Joe Gould, the homeless Harvard graduate, whose unfinished life's work, An Oral History of Our Time, among other things, made him a roving landmark of the Greenwich Village for decades. In Mitchell's later years, as a City Landmarks Commissioner and as a charter member of the Friends of Cast-Iron Architecture, it became his habit to carry a pair of binoculars on his habitual walks around New York. He died in 1996, but it's nice to imagine that Mitchell would have been among the first to spot Whiteread's lofty sculpture. (On a more guerrilla note, did he ever spot Richard Artschwager's big blp, a remarkably abstract graffiti, when it graced the Turtle Bay Steam Plant smokestack on 34th and Fifth Avenue?) And that he would have appreciated its off-beat and pleasant proof of this city's particular capacity to inspire whomever is simply prepared to look.

—Ingrid Schaffner, curator, New York City

I noticed that there was something going on. I went to the site and I talked to the foreman. Somebody inside helped me. I gave him $1,000 cash. Nobody asked questions about it. The Turtle Bay Steam Plant smokestack was due for a paint job. So my blp went down with the painting instructions. I had thought of doing it myself, but it was such a huge undertaking. I don't think that ambition is a generational thing because Rachel went after it too.

—Richard Artschwager

Seeing it on an overcast day, it becomes completely contiguous with the sky. The object looks like an airbrushed drawing, a translucent ghost of an existing water tower. The dunnage doesn't help it because it doesn't look authentic. I guess it was a tricky circumstance to site one. It's like having an existing pedestal for a sculpture in a museum.

—Diane Lewis

Plastic is a phenomenal substance. There is something like 64,000 polymers, based on just seven families. It's quite overwhelming but as you go through the experience of working with plastics, it all becomes quite self-evident. The material aspect of plastics, particularly when we get to "smarter" materials, is the most fascinating. What I like about Rachel's work is her material exploration and her shift into the industrial cosmos.

—Karim Rashid

The ice in a skate-rink has a particular color. Like all ice, it is ice-colored, but rink ice has a mysterious haze that reflects a bottom which is never seen. Whenever the blades of my hockey skates would kick up a snow of shavings, I would look for the bottom to see what color it truly was. Was it blue or was that my imagination trying to put the sea underneath? Seeing Rachel Whiteread's tower reminded me of this. It too has a mysterious inside, an endless middle, and an outside you want to scrape away to find out how deep it goes.

—Collier Schorr, artist and writer, Brooklyn

The engineering specs called for strength characteristics so we had to develop a system that would not change color with ultra-violet rays and which would withstand other environmental problems that could color or distort the material. This technology is everywhere around us, such as in clear polyurethane coatings, industrial products of all kinds. The technology of WC783 is proven to withstand chemical and environmental situations. What's not proven is how far one can go with making a huge mass of material and having it not burn up or malfunction. This is where we came into play. We've had a chemist working on this product line for about 15 years, constantly upgrading it. The challenge was to adjust the formula to meet the needs of Water Tower. There were many potential disasters. The Public Art Fund and Charles Hickok came and worked with us here and we all had a very good understanding of the project and what technology we could employ to help them accomplish the work. You have to think positive to do something like this.

—Brian Stransky

Water Tower made me think about Louise Bourgeois' involvement with water towers; the wood from which she made a number of her early pieces came from water-tank scrap, timbers either discarded or replaced. Her work during that period was made out of two kinds of wood, balsa and what she found. So she found her freedom on the rooftops of New York with these materials. When Louise was first making sculpture, she would put her figures on the roof in clusters, the way she eventually put them into galleries.

—Robert Storr

Water Tower took 9000 lb. of material, which is phenomenal. During the time that it was in liquid form, as fast as it was being pumped into that mold cavity, the amount of gravity pressure on the mold was tremendous. People don't realize that if you had one inch of water against the Hoover Dam all the way up to the top, it would produce the same amount of pressure as the whole lake does.

—Brian Stransky

SoHo is the home of monumental installations such as De Maria's Earth Room and Broken Kilometer. Earlier in the 1990s there was a discussion about closing them down because they have become so expensive to maintain in the current real estate situation. With SoHo changing, I had a sense that maybe you would do that after five or ten years; but after twenty years these installations are embedded in another time; they belong to some larger history or context that shouldn't be touched. Strangely, the Water Tower is going through that same phase much more quickly, maybe at a speed proportionate to the demise of SoHo as an art center.

—Michael Govan, Director, Dia Center for the Arts, New York City

A new urban myth: Water Tower provides irrigation for Earth Room.

—Jon Kessler, artist, New York City

In 1972 Trisha Brown choreographed a work called Roof Piece that was performed on SoHo rooftops among the water towers. I thought about this piece when I saw Rachel's water tower. Though of different generations, both artists have claimed non-conventional spaces for their art and transformed our perceptions of those spaces. The gestural space created by the dancers finds an analogy in the translucent space of Whiteread's water tower. As a choreographer, Trisha has often explored (and defied) gravity in her pieces, while Rachel's sculptural work reifies the negative space so that what's solid and what's air seem to change places. Trisha has turned a rooftop, a ceiling, a wall—even the wall of a building—into a floor, while Rachel Whiteread has turned inside into outside, air into matter, and matter into air.

—Anne Livet, President of Livet Reichard Company Inc, New York City

Subtle slap in the city's eye. Faint luminescence on a rooftop, dependent on weather; word of mouth; a glance caught unaware. As such Water Tower is pure contingency. I first saw it on a cloudy day. Duller in texture than I expected, and smaller; out of the way. Yet every water tower I now see (and how many more I do) has been transformed in the mind's eye into just such a frosty opaque possibility. Water framed by quiet, articulate form rather than function, forgotten.

—Thyrza Nichols Goodeve, writer, New York City

I think Water Tower has something to do with peripheral vision, because you are looking for something and all it takes is to identify one element in the periphery and the rest of the periphery becomes evident.

—Michael Govan

For me, Water Tower has been not so much an object as a game. For nearly a year I had the luxury of subletting a SoHo loft with—miracle of miracles!—a roof garden with extensive views. And in Manhattan, a roof view means endless vistas of other rooftops' water tanks. I knew that one of them was a ringer: Whiteread's blanched simulacrum. Somehow I had to divine which it was. At a distance, there would be no making out the difference in materials. I decided it had to be the palest one of all—the ghost (to borrow a title from one of her earlier works) of a water tower. But as it turns out, more than a few of those in the neighborhood are lighter in color than the dark, weathered gray that comes to mind when I think of a water tower. In the end, I think I've figured out which one it is—the one that seems to be about four blocks south and maybe two west of where I am—but I know I'll never be sure. Still, Water Tower made me a spy in the sky, provoking active, searching perception in a way that the artworks that I'm sure I've seen rarely did.

—Barry Schwabsky, art critic, New York City

From the street the tank is quite formal, but up there, close underneath it, the H_2O becomes kind of schizophrenic. You get the void of the H_2 and the lightness of the O, which makes you worried and relieved at the same time.

—Francesco Bonami, curator, Museum of Contemporary Art, Chicago

Usually we use this resin very fast. For Mr. Freeze's ice in the recent production of Batman, we took the same mother product but we had to accelerate the resin's work life to 30 seconds so that the material could freeze in mid-air. We went the opposite way, devising a very slow system with a three-hour work life.

—Terry McGuiness

What's it made of? Ice?

—Anonymous passerby

If Rachel Whitehead had erected Water Tower in London, it would have been a cause célèbre, like House; but in New York, no one seemed to know what, or where, it was. Thinking it was above Grand Street and Broadway, I scoured the skyline, and walked so far along the cross-streets that I found myself in Chinatown. A friend had said that its visibility changed with the light, so I could never be sure if I'd suddenly glimpsed the silhouette in an apparently empty stretch of sky. After a while, I told myself that it didn't matter whether I actually saw the sculpture, because it had been fun staring up at the rooftops, at a part of Manhattan I usually ignored. Well, I was wrong because, when I finally found Water Tower, it was so enchanting—beautiful but absurd—that I laughed out loud. Staring up at the roofline, its silhouette was clearly visible against the sullen clouds. It looked like a large lump of ice that might melt at any minute if its sturdy truss hadn't lent it such a reassuringly solid air.

—Alice Rawsthorn, journalist, The Financial Times, London

A luminous ghost of a water tower—which is not one. Not a ghost, really, but light itself, materialized. Not a water tower but its double, cast in light. The incandescence of the resin makes it clear that what we are looking at is not a replica of a water tower but rather a form given to the process of replication itself, to the "re" in recasting. Or, to put it differently, if mimicry may be redefined as the fabrication of the same but not quite, what Whitehead's mimicry yields is the "not quite" itself, a morphology of a kind of absence. This is where, in my view, the intelligence and power of her formal gesture resides: It opens up the very hiatus between being and seeming to view. And thus it enlightens us. To see—differently.

—Ewa Lajer-Burcharth, art historian, Harvard University

What? No, I don't need to see it.

—Anonymous passerby

Usually wells are underground, but here in New York they're overhead. I moved into 80 Wooster in 1967 and we didn't have running water throughout the building. We had to go down to the basement to get it in buckets. There was sand on the floor, I don't remember why. So there was this curious thing about going down to the well and going up to the well. The water tower is a very primitive thing.

—Trisha Brown

Trisha Brown, *Water Tower Piece,* SoHo, New York City (1972)

You never know it until you see it or experience it. This way, the act of defining things creates a mind-space and the idea or memory of it is just as important as seeing it. Looking for it is almost just as satisfying as finding it.

—David Zwirner

I'm the answer man when people have questions on how to work with the materials, what they should use, how they should make a mold and so on. We became involved with the engineers to do structural testing on the materials for Water Tower. We did several test pours to figure out the exotherm of the material, as that would help the fabricator design his mold, and we were in charge of getting the material into the mold. The pumping time was about four hours. It was quite an experience because of the confined atmosphere of the building and the amount of the material we had to move around.

—Terry McGuiness

Does Rachel Whiteread draw attention to the hermeneutics of water towers? Does she change the way we think about water towers? As a resident of London rooted in the eighteenth century, maybe her sensitivity made her see these homespun sentinels. Maybe she is attuned to the water tower's forlorn poetry. Unlike the cool minimal concrete sculptures of the Bechers, water towers are of wood, therefore nostalgia kicks in. Her elegant sculpture is something to remember—as we march in lockstep towards a glorious city of Future Light.

—Sam Samore

On February 13, against a brilliant early afternoon sky, Water Tower was a radiant ghost, an inexplicable visitor in conversation with two earthling cousins. These everyday presences are now mysterious, too, and I think they will remain so even if the visitor should ever go away.

—Joseph Holtzman, editor, Nest magazine, New York City

I was a design engineer in the aerospace industry, which is just about as abstract to people outside it as the art world is. Much of it is restricted knowledge and information. With this project I was getting back into what I did for the aerospace industry. What we did there were full-sized test models of the air crafts, ships, and helicopters, which would take quite a lot of work and planning. Some of them were very elaborate, some were very simple. I'd been wanting to get back into something that would allow me to put my experience back to use, so it was good to work on a large project, to get people together who knew it could be done and had the will and experience to do it.

—Chuck Hickok

It's like a virus, which is a very contemporary paradigm. A virus makes itself visible by replicating and corrupting existing files or cells. Water Tower has replicated itself from something, but as a foreign body in a strange material. It is a subtle disruption in a landscape of familiar things.

—Anonymous observer

Rachel's work is very much about the retention of memory and objects and spaces that are imbued with a certain kind of memory. The whole notion of casting as a way of retaining traces and preserving forms is not necessarily a nostalgic endeavor. For her to pick up on the water tanks is to pick up on a specific rather than a universal structural form and one that is explicitly related to a certain kind of environment, a certain kind of city. It's also about exposing memory.

—Terence Riley

Polyurethane will be with us for a long time to come because it is used in everything, from soft upholstery to rocket windshields because of its "memory." Memory is what makes soft resin spring back into shape, for example, when you get up out of chair.

—Karim Rashid

Comparisons are being made between Water Tower and the work of "urban terrorists" such as Gordon Matta-Clark and Robert Smithson, who infiltrated or challenged our understanding of the urban environment. Smithson's work was very much about the destruction and decay and morphosis of natural elements; Matta-Clark was very interested in mischief; of assemblage and de-assemblage; of construction and deconstruction of architecture; of shapes and fragments rather than wholes; Whiteread is more interested in entire forms and silhouettes. So I think in this sense Water Tower relates more to the realm of photography. It has a remote quality, like those fragile prints from a vintage 5 x 4 in. camera in which the presence of image might vary greatly from one print to the next. Sometimes it's there and sometimes it isn't.

—Alanna Heiss, Director, P.S. 1, Long Island City

All immigrants to New York have a romance with its skyline. This is a tribute to that feeling. I had a religious feeling about it. It has something Indian, astronomical, about it, something of the observatory in Jaipur or the Taj Mahal. A joining of earth and sky.

—Clarissa Dalrymple

A water tower is a combination of very pure forms, a cylinder with a conic section; from a straight Cubist point of view, this is the perfect element. Juan Gris said that's what cubism was about: The first step was to turn bottles into cylinders and the second step was to turn them back again.

—Robert Storr

What about the idea that she makes the building the pedestal for her sculpture — is that an original proposition? No. Too many examples to prove otherwise. What about the idea of entropy à la Smithson? The Water Tower is groovin'. What about the idea that she is transformed like a butterfly from the cocoon of her apprenticeship? From the "ugly" House to the "beautiful" Water Tower. What about the idea that she wants to construct a new kind of androgynous penis? Friendly/sweet water towers don't threaten. A variation: she goes from the interior feminine (inside house) to the phallic (outside tower)? What about the ecological drama? Her sculpture says: there's no more need for another "functional" water tower to supply us denizens with fresh water, we are all going to die anyway!!! Or: our thirst for art has killed us. We've dried out — preferring her "emptied" water tower to "the real thing." This one reminds me of seventies behaviorist studies demonstrating how rats will starve to death if given an unlimited supply of cocaine. Given a choice between the either/or of sustenance and art, we must choose art.

—Sam Samore

Water Tower is a time capsule in that it is an image of imminent obsolescence because buildings are getting bigger and need stronger pumps for water supply. I think the reason why they still even exist is because these buildings are co-ops, and they are landmarked; thus existing infrastructures are perpetuated. Also, art has become an artifact in a SoHo now dominated by boutiques and shopping and tourists. Water Tower inadvertently acknowledges the beginning of that end.

—Kirby Gookin

Water tanks are there but we never really see them because we're used to them, like yellow cabs. If you do stare at them once in a while, it's mind-boggling what effort went into designing all the different trusses they sit on. They sit on different buildings at different supporting points so the structural solutions are adapted to meet all those differences. They usually weigh 80,000 pounds or so, depending on capacity. That's a tremendous weight sitting on top of these buildings and you have to bring the weight down to where the building can support it. I've designed the supports for tanks. Tanks also go into new buildings, sometimes concealed, but exposed tanks are still viable and cheaper. Most buildings in this country are built from wood. There is a huge resistance here to change how we think about the construction of a house and what new materials can be used. For example using steel studs instead of wooden studs, although it has some disadvantages, is the way of the future, because wood is such a perishable and overused material. But there is a great resistance to attempt to use something new in an environment where people have done it successfully the same way for so many years. And that's the story of the water tank. It serves its function unchallenged, so why redesign it?

—Mark Hage

I've seen it mostly at night, when it is at its best. It's very spectral, illuminating, aglow. It's the antithesis of the medieval tower, the technological end of what began long ago, and a fitting epitaph to the community which has had its heyday, although there will be art in SoHo, it will go on. Water Tower freezes that memory in time, like the memory of water.

—Burt Barr

Myth rushes in where there is vacuum of facts. Facts are expensive to reconstruct and there is no incentive for the water tank companies to understand closely the history of water tank construction at the top of buildings. What's in it for them? It's not going to get them more jobs. Therefore, the details of water tank construction in early high-rise buildings, say during the 1870s and 1880s, remains unknown.

—Christopher Gray, Office for Metropolitan History, New York City

The history that is inscribed in this sculpture gives it a personality. People talk about high concept, but the content of Rachel's work is so specific to the object being cast and how it is cast, it develops all kinds of idiosyncrasies. I researched the original water tower at 60 Grand Street, which was built in the early twentieth century and torn down in 1989. This anonymous water tower came to gain a specific identity through my contact with the people who had been previously involved with it. So although it was initially perceived as being anonymous, it is in fact touchingly full of character.

—Gregor Clark

Wooden water towers are one of those ubiquitous aspects of New York urban culture which rank right up there with the orange and white striped steam—exhaust tubes that are intermittently placed around the city. It's something that no one ever designed, that no architect or engineer or artist ever had any part in realizing, but they are like the gondola poles in Venice, or red telephone boxes in London. You could come up with some iconic sculptural reference for every city.

—Terence Riley

Lothar Baumgarten made a work about the chimneys of Venice, inspired by the Canaletto paintings that have all the chimneys in them. The chimneys were often architectural learning assignments in style and form for young architects. There is something about those Canaletto paintings and their chimneys. You could look just at that. It's an entire civic architecture right there, an architecture without architects. Those chimneys are not unlike looking at the water-tower rooftops of New York; of course in a European sense the chimneys all have design and they all relate to particular styles, but in an American context they are all purely functional, yet they have their own vocabulary that evolves from that.

—Michael Govan

I remember coming to New York from Germany and being really intrigued by the water towers because I saw them as sculptures which also served a function. I'm really happy that she placed it in SoHo because, when the dust settles, SoHo is going to be synonymous with a certain period of the arts and Water Tower went up just at that moment when the emphasis from SoHo is shifting to another neighborhood, namely Chelsea. I hope it will stay permanently. I think it's a great piece of art for this part of town.

—David Zwirner

Moving it into a gallery context could be interesting because either it will look like a big prop, or it could be a wholly different experience of its material presence, a new sculpture. This brings up questions of specificity in terms of refinement and scale.

—Karim Rashid

The most interesting artists of our time are forced to think outside of the gallery because the gallery is full of conventions and constraints. It must be very liberating for an artist to do that. I can only hope that this will set an example for other people to get some work in the public realm. I think a lot of artists would go this route because most existing public sculpture is completely anachronistic at this point.

—David Zwirner

In the 1970s, what was integral to the metaphor about making art was simply the will to act, in this case, by appropriating buildings. I didn't obtain access for Roof Piece—I took it. When I asked permission from the owners of a building to place a dancer on their roof, I was told that their insurance company would not allow an unauthorized person up there. That's when I knew that SoHo was "over" in a way. That's a whole other big issue, the "greening" of the art world. And yet, I got my first National Endowment for the Arts grant to do Roof Piece, which indicated to me that the NEA was not just funding large ballet companies.

—Trisha Brown

I've been very lucky to pass by Water Tower on a daily basis, twice a day, ever since it was installed. I see it from a point of view of someone who is in the neighborhood and sees it is just part of the general surroundings, rather than from the point of view of someone making a special trip to see Water Tower. For me, the most extraordinary aspect of it is how it changes, it is different at every moment, in every light condition, every time of day. Sometimes it's like a mirage, sometimes it's like a glowing beacon, sometimes it's purely architectural and I love experiencing these changes in how it presents itself.

—Jeffrey Deitch

Water Tower made me appreciate a formal structure that might at first seem passive, but because of its chameleon-like character, it activates your mind, your thoughts, your curiosity. On sunny days, it glows pale-green in the sky above the dingy roof tops. On overcast days it absorbs the gray of its surroundings, and fades into the ether. It continually provokes the attention of passersby who happen to glance up at the sky. I've often seen people standing about the corner of Grand and West Broadway pointing up as if they were seeing Superman.

—Kirby Gookin

Whiteread's Water Tower is a very public and sentimental statement, sentimental, I daresay, as only a foreigner could be. It is curious how foreigners and exiles, not usually the best at reading between the lines, seem to show a special sensitivity toward punctuation, toward the strong details that make a city. Just like water towers in New York.

—Paola Antonelli, curator, Department of Architecture and Design, Museum of Modern Art, New York City

From Canal Street, looking uptown, the piece is translucent. It reminds me of how New York is disappearing. For every new Starbucks and Barnes & Noble, for each apartment that is renovated and priced at its new market value, some other place, some other shop, some other people have been displaced. This city is changing so quickly, some call it progress. This piece reminds me, again, about what is being lost in that process, what is being replaced.

—Zoe Leonard, artist, New York City

The water towers that dot the downtown skyline persist as strangely comforting, almost humanoid structures, sporting pot bellies and black caps. They are relics of a more intimate and smaller-scaled past, before Manhattan turned into a museum of itself. What drips out of Whiteread's translucent tower is not liquid, but a flow of memories of the city's lost history.

—Daniel Pinchbeck, editor, Open City journal, New York City

Whiteread is drawing on several traditions that are very interesting for making a sculpture in New York right now. One, of course, refers to the American Precisionists, like Charles Sheeler and the photographers of that school who specialized in this kind of view of New York City. Then there's the aesthetic of SoHo in the 1970s, with artists like Gordon Matta-Clark who enabled space and environment to be understood in a totally different way. On top of this is the European aesthetic, photography specializing in bizarre, anachronistic early industrial structures that still remain but are really not part of this world at all. She's bringing all of these references to bear as well as the very contemporary issues of fiction versus reality. These issues have permeated art ever since Duchamp and Jasper Johns and are still absolutely central.

—Jeffrey Deitch

It just looks like a transparent water tower. They're not made like that now, but they may well be in five years' time. When you see it, it's just another strange element in the visual clutter of New York. I don't think anyone would stop and say, "Hey, what is that mysterious object?" Do you?

—Adrian Dannatt, writer, New York City

Rachel Whiteread's beautiful water tower shows—again—how ghosts, all light and lack of substance, impinge with their presence more lingeringly than solid and weighty looking earthbound phenomena.

—Marina Warner, writer, London

Typically, artists seem to be in limbo between understanding the magnitude of their technical ambitions and yet seeming to want to maintain a Luddite approach. I think the reason is twofold. The most difficult thing about doing unique things is that you can't afford to invest in major tooling because it's phenomenally expensive. It's geared to mass production, that is 50,000 items and over. Of course this is distinct from the way the art world functions, which is on a much smaller scale of distribution. There are, however, certain tools that are geared to small production and start self-destructing as they are used, so that this deterioration can then become part of the customizing of the production run. It's obvious that there is a perceptible divide between art and mass-produced objects, but this is not to say that the grey area could not get larger and I hope it does because it's a very interesting problem. It's a very fertile area for development.

—Karim Rashid

If there is a permit involved for Water Tower as a sign, then that's just an annual cost and it should be endowed. Someone should just put the money down to secure it. It should stay there, like Earth Room and Broken Kilometer.

—Richard Artschwager

I still look at Rachel's sculpture often. What fascinates me is how the elements affect its appearance: a bright day, a cloudy day, the position of the sun. I often take industry colleagues from out of town to see it, and I tell them that this is something absolutely unique; that they will never see it anywhere else; that they must make a point to stop and look at it, and to look at it more than once because it will always be different.

—Richard Silver

I hope that it stays where it is. I think that it would be a shame for it to be taken down and relocated. Its impact will only be strengthened if it can remain and slowly merge into the local environment.

—Jeffrey Deitch

When you cast something it becomes completely other. That Whiteread has cast the idea of the inner space of a water tower, not a physical replacement of the water tower as an object, gives me a whole new understanding of her work. It's interesting in terms of casting the city, because it's not only physical but mental. So if it's possible to reread a piece of the city and cast it, both physically and programmatically, it's a new act upon the civic body. That's why it could lead to new elements of architectural urbanism. The city is a text and the problem in architectural urbanism is that everybody is arguing about the city as history, meaning collective, objective history. But an existential description of the city as a history is that history has no objective, the art is to give it one, by reading of the city not as a history but as une histoire, a story. To bring the imagination of one soul into dialogue with the collective, repetitive function of mass is a poetic act. This is the possibility for the artist and the architect in the city. Alberti said that the city is a house and Plato said that the house is a city. By adding elements to this house that we live in, you redefine the life in the house. That's where urbanism becomes exciting.

—Diane Lewis

I don't look at it much now, but I love that it's there. It makes me feel good the way I used to feel good about John Lennon living in New York. When he was gone, I felt pretty bad about New York. If Water Tower leaves, I think I'll feel slightly diminished, won't you?

—Jerry Saltz

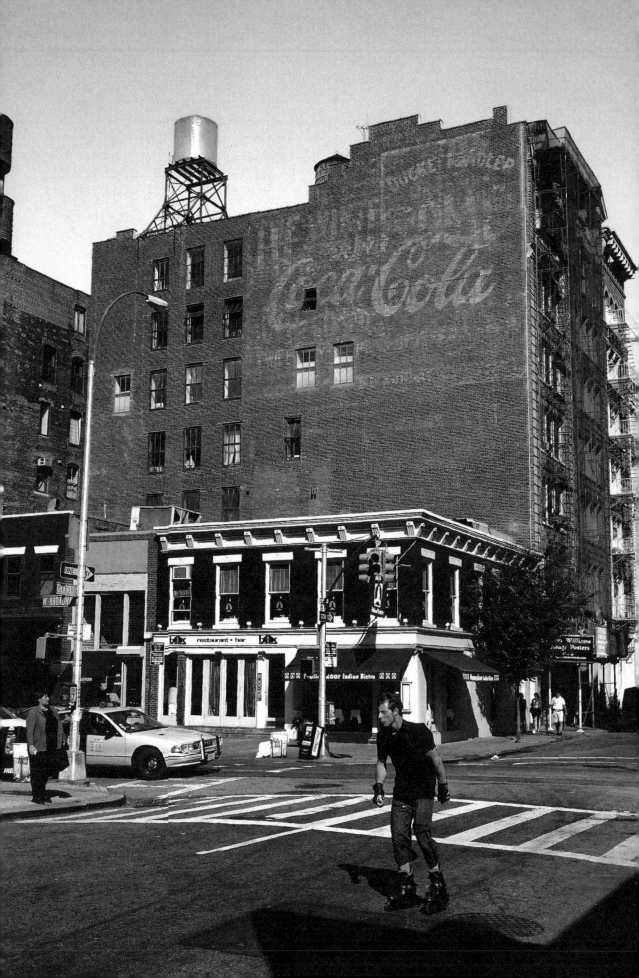

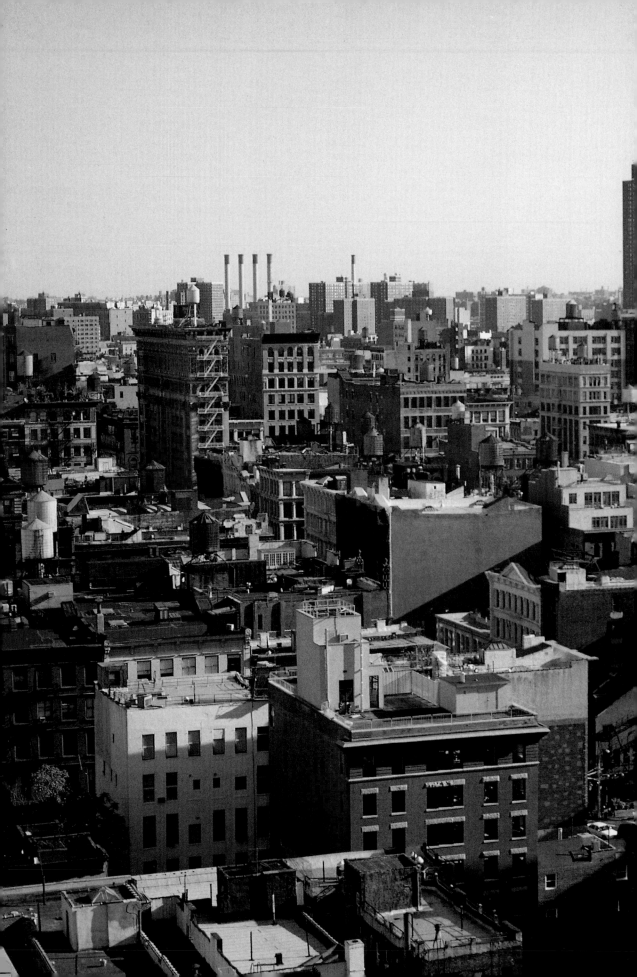